D1389753

700041802466

Robert Lebron

"You Got It Kid"

Albert L. Rolon

outskirtspress
DENVER, COLORADO

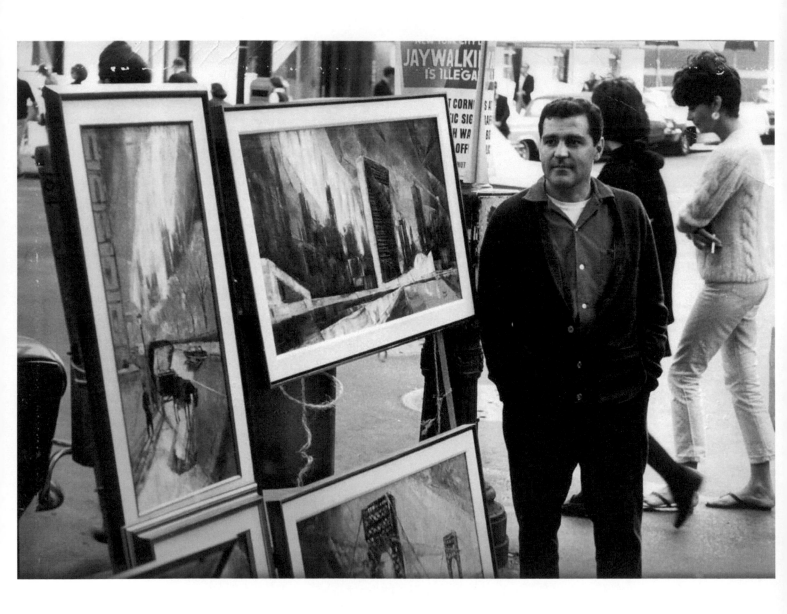

Robert Lebron

Greenwich Village Art Show

1968

I would like to thank Sandi Lebron and Christina Greear for all of their hard work and dedication during the production of this book. – Albert

Front Cover Image:
Harold Square
Signed Lower Right
30" x 40" 1999

Preface

This book is the culmination of a strong friendship, admiration of talent and desire to share the art of Robert Lebron. The journey that led me to meet Robert began shortly after the passing of my grandmother. My need to cherish her memory led me to commission a portrait of her. During the search to find an artist to complete her portrait I met Robert Lebron.

After researching him I found that although he was not a portrait painter, he did have several things in common with my grandmother. They were the same age and were of the same heritage; this sparked my curiosity and, as I studied his paintings, I felt a connection to his art, having grown up in the shadow of the city he often depicted, New York City.

I located Robert teaching at a local gallery – remarkably only thirty minutes from my home, I called and made an appointment to meet with him. I thought our first meeting would be short and to the point, but he began telling me stories about his paintings, his formative years in art, and his ultimate move to Florida. This meeting ended with the commission of my grandmother's portrait based on a black and white photo I owned. Even after the painting was finished we kept in constant contact; we began to meet regularly, once or even twice a week, and talk about anything and everything that came to mind. I found that Robert and I had shared interest in politics, travel, and classic movies.

Before the portrait of my grandmother was even completed I began to collect Robert's paintings. In the beginning I searched for paintings that reminded me of New York, but as the collection grew so did the subject matter. I began to acquire paintings of Spain and upon seeing these pieces Robert would reminisce about his trips to Malaga, Spain in his younger years and the amorous adventures found along the way.

During many visits we would look through photographs that Sandi had saved of decades of Robert's work. We would discuss everything from his technique to choice of subject matter. He would tell me the stories behind his paintings and I got to see first-hand his imagination at work. I saw how from a blank canvas he would create beautiful works of art purely from his imagination; even though he was in his mid-eighties he didn't miss a step.

Unfortunately our friendship would be cut short by his sudden death in August 2013. His quick decline in health left both my family and I deeply saddened and we continue to visit Sandi and assist her whenever needed. It is with her support and patience that I undertook this endeavor to keep Robert's art alive for generations to come.

-Albert L. Rolon

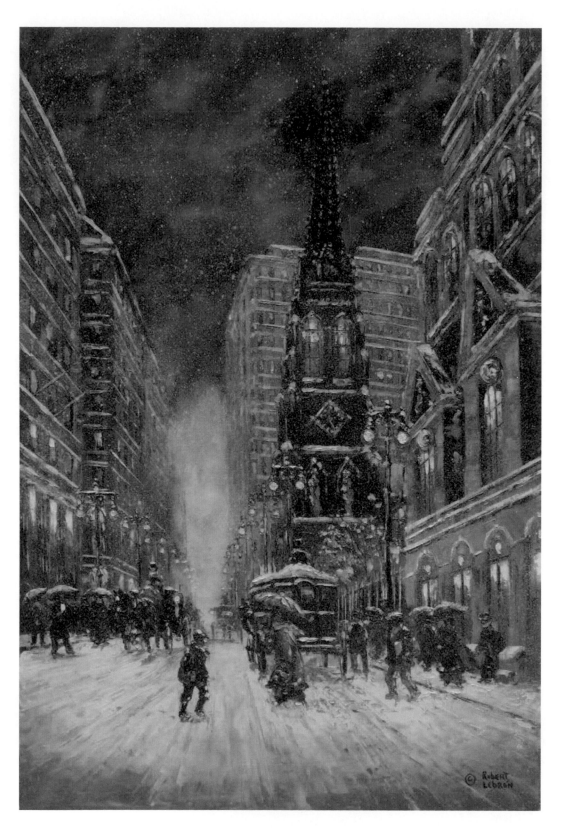

Trinity Church in Winter
Signed Lower Right
36" x 24"

Among the many artists of the twentieth century, Robert Lebron has distinguished himself through his depth of color and renditions of remarkably accurate cityscapes, which makes it hard to believe that they can all be accomplished with a palette knife.

Robert Lebron, a native New Yorker, was born on March 13, 1928; he barely made it into this world, weighing only four pounds. His parents were so overjoyed that their infant son had survived such a difficult birth that they named him "Robert" after the doctor who successfully delivered him. Robert was the second of three children born to Domingo and Carmen Lebron, both of whom migrated separately to New York from Puerto Rico in the early 1920's.

His father, fairly educated for the time, worked for the United States Post Office in New York City, while his mother tended to the children in a small apartment in Spanish Harlem better known as "The Barrio." Times were tough in 1931 depression-era New York both financially and emotionally for the Lebron household. Domingo and Carmen's relationship began to strain and, now expecting her third child, Domingo arranged to send her back to Puerto Rico where she could live with her mother. Domingo promised that he would join the family as soon as a transfer from the Post Office came through. He never did. The marriage ended all too quick and too soon for Carmen.

Carmen Lebron
Robert's Mother

Robert, along with his mother and older brother, Ralph, settled in at his grandmother's home in Playa De Ponce in the southern part of Puerto Rico. His youngest brother Paul was born shortly after. In this serene beautiful beach community is where Robert first experienced drawing at the age of three. This experience came when Carmen's cousin, a fisherman, would bring in a weekly supply of huge Blue Crabs and freshly caught fish. He would also bring old paper bags and pencils for the boys to draw with. These paper bags and pencils were meaningful to Robert and would lead to all the boys settling on the floor and drawing everything they could think of. This ignited the

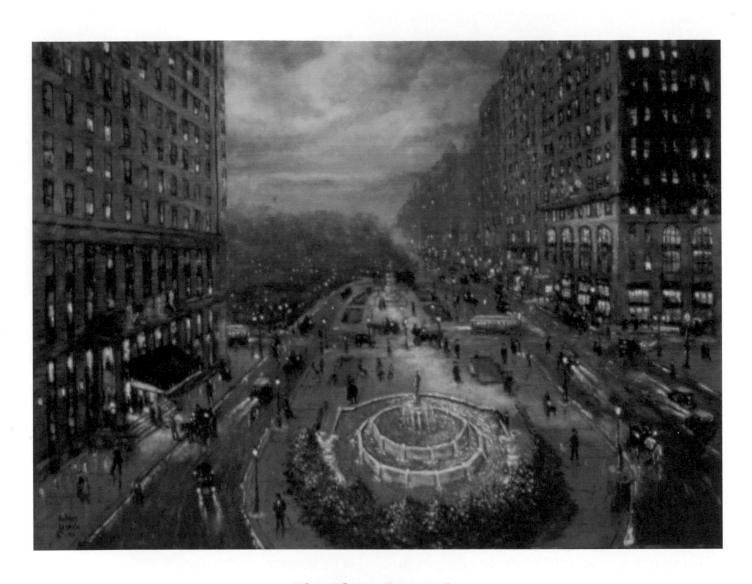

The Plaza Fountain
Signed Lower Left
30" x 40"

passion, in Robert, for drawing—that passion would last all of his life.

By 1935 his mother was longing to return to New York City. She decided to pack up the boys, boarded the S.S. "San Jacinto," and returned to New York. On July 29, 1935, Robert sailed into New York Harbor and once again was a New Yorker. He recalled that he was taken aback by the utter amazement of the New York Skyline at night. Having come from a little village in Puerto Rico where all they had was three streetlights, this, to him, was like stepping into the future.

Robert was later enrolled in P.S Number 170 and met a teacher, named Miss. Marion, who fused his love of art with his fondness for history. With exposure to literature such as Pinocchio and the Arabian Nights, Robert's desire to illustrate all those wonderful characters began to occupy his time. Robert began to venture out for more inspiring characters for his drawings. On Saturday mornings he would attend the matinée showings of serials, such as Zorro Rides Again, The Black Eagle, and The Lone Ranger, among others, and would find himself rushing home to recreate the characters in his drawings. As Robert continued to mature so did his discerning eye for art. When Robert joined the Boy Scouts he was quick to notice the illustrations of Norman Rockwell in their handbook. Although he was not aware of whom the artists were at the time, almost any book with N.C. Wyeth's illustrations would also catch his eye and admiration.

Robert Lebron 1939

In the early 1940's Robert qualified to attend the hard-to-get-into New York High School of Music and Art. One of Robert's first jobs, while attending this school, would have a profound effect on his future depictions of New York City. Robert was a delivery boy for Spiro's Flower Shop; this shop serviced the big hotels nearby on Central Park South. His familiarity with hotels such as The Plaza, Sherry Netherland, St. Moritz and St. Regis, along with individuals such as Hansom carriage coachmen, doormen and cabbies, would leave a lasting impression on Robert and influence his paintings for the remainder of his life.

Robert's creativity seemed to always be fueled by a longing for old New York, the New York you see in the old 1930's movies, with men in top hats accompanied by elegantly dressed woman. When he spoke about the fashion of today Robert would always complain about today's fashion pit—that sneakers had replaced patent leather shoes and apparently sport shorts and T-shirts had replaced tailored suits and slacks. He conceded that the casual attire was more comfortable, but still the elegant Cary Grant look was something he would always miss.

Robert decided to join the Air Force in February 1946; although still under age, he forged his parents' signatures on the consent forms and left. Robert's interest at this point was drawing cartoons; he dreamed of being employed by one of the newspapers to do a comic strip like Li'l Abner. After being assigned in 1947 to Chanute Field, Illinois, his first stop was the nearby Chicago Art Institute. The only artist he could even slightly grasp was Toulouse Lautrec, perhaps because Lautrec's linear technique and comic renderings of his many subjects were close to Robert's own style.

THE ART SCENE

THE SMILE? WELL SHE LAUGHED BROADLY ONCE, AND DISPLAYED A FEW TEETH MISSING.

Drawing by Robert Lebron
Illustration Board
10" x 10 ¼"

Robert decided to put some samples together for the camp newspaper, which was more professional than most service journals, except for their cartoons. He went to their Editorial Office and got the job as cartoonist. Robert was content drawing the cartoons until he heard about the Air Force Motion Picture Unit's need for an animation artist. He rushed over to their office and presented his drawings. After much shuffling of papers and the fact that they could use more help to pack their equipment, it qualified him for the quick transfer to the unit and their new headquarters in New York City.

By 1949 Robert had left the Air Force and enrolled at the Art Students League in New York City. There his teacher John Stapleton Kenny influenced him. Kenny was an Art Professor at the University of Maryland. He not only taught drawing and painting, but would join Robert and fellow students after class at a local restaurant where he

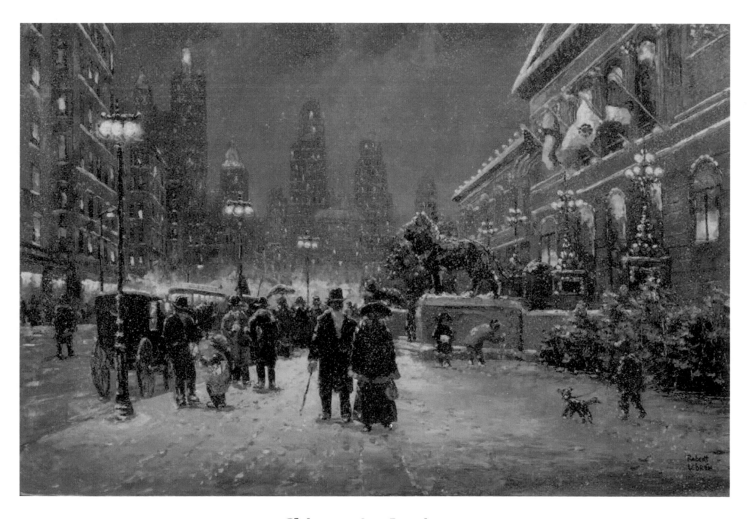

Chicago Art Institute
Signed Lower Right
30" x 40"

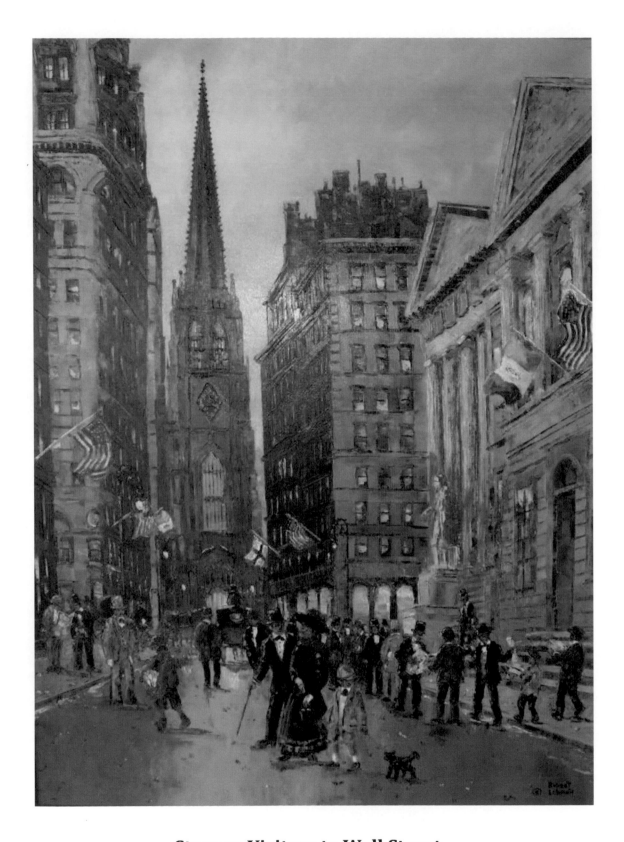

Strange Visitors to Wall Street
Signed Lower Right
40" x30"
Featured in the game show Jeopardy on Feb. 19, 2013

talked about wine selection, French culture and Art History. Robert was also instructed by Reginald Marsh at the Art Students League, an artist famous for his depictions of New York City, who quickly became one of Roberts's favorite instructors. At the end of the first day of class Mr. Marsh approached Robert's easel, looked at his drawings and said, "You've got it, kid, just stay on course." At first Robert didn't believe him; however, in the few months Robert attended Mr. Marsh's class, he never heard him praise anyone else.

The dream of becoming a full time artist still remained out of grasp. Robert, seeking employment, answered an ad placed on the bulletin board at the Art Students League. The ad said, "Wanted, young man to work for art dealer, stretch canvas, some minor restorations." He applied and was subsequently hired to work for Mr. Leopold F. Landsberger, a Jewish holocaust refugee from 1939 Austria. Mr. Landsberger descended from a long line of art dealers and was a reputable wholesaler of imported European paintings. Robert was surprised to discover that in the wholesale art business the paintings were simply merchandise. An inventory number would be put on the back of the canvas and stored just like any other item; there was no appreciation for the work. This new world of art had a business aspect just like any other. Shipments of rolled up paintings would arrive from all over Europe in large tubes, some with as many as twenty canvases. Besides stretching canvases, Robert also completed restorations of paintings damaged during shipment.

While working for Mr. Landsberger Robert saw his first Edouard Leon Cortès painting. It can only be described as love at first sight. Granted he was being exposed to hundreds of new artists while working for an art dealer, but Robert was drawn to the beautiful deep somber colors, the radiant light reflecting on the wet streets and the overall mastery of the spectacle of the Paris street scene. This initial viewing of a Cortès painting made Robert want to purchase one for himself in the future. Mr. Landsberger allowed Robert to take one home for the purpose of making a study copy. All the drawing and painting Robert

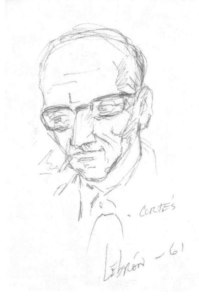

Sketch of Edouard L. Cortes
Ink and Paper
7.5" x 6"
Dated 1961

completed up to this point left him ill prepared to capture the radiance of a Cortès.

In 1955 Robert started exhibiting in the Greenwich Village Art Show; he exhibited eight paintings he'd completed in school. After five weekends he still had all eight paintings. On the final day of the show he was offered $15 for a painting originally priced at $35. Robert declined the offer and the painting remained with him as a constant reminder of his early struggle to be recognized as an artist.

By about 1957 Robert's plans of being recognized as an artist were beginning to take shape. He began to sell paintings to Mr. Landsberger, mostly of his Central Park scenes and, at the next Village Show Robert, was rather successful with total sales of $500. His dreams of traveling to Europe were beginning to look much more realistic. Two years later Robert was making enough money to give Mr. Landsberger his notice. Robert agreed to stay on through Mr. Landsberger's forthcoming buying trip to Europe and until a suitable replacement could be found. Robert was still looking for a more comfortable style and the palette knife was becoming more important in his technique.

Robert's amorous adventures finally caught up to him in 1960 when another struggling artist, Shirley Miller, told him that she was carrying their out of wedlock child. Robert never married Shirley, but kept his financial obligations as a father. Even with this new-found responsibility to Shirley, Robert saved enough money from selling his paintings to make his pilgrimage to Europe. His dream of seeing what inspired all the great painters of Paris, London, and the rest of Europe was coming true.

Robert heard about a Yugoslavian freighter that would carry passengers to Tangier in North Africa, and then it would be just a couple of hours via ferry to Gibraltar and Spain. The 10-day voyage in 1960 was all-inclusive for the princely sum of $130. Once he reached Tangier and

Student Work
Robert's painting he retained from his 1955 art show as a reminder of his early struggles

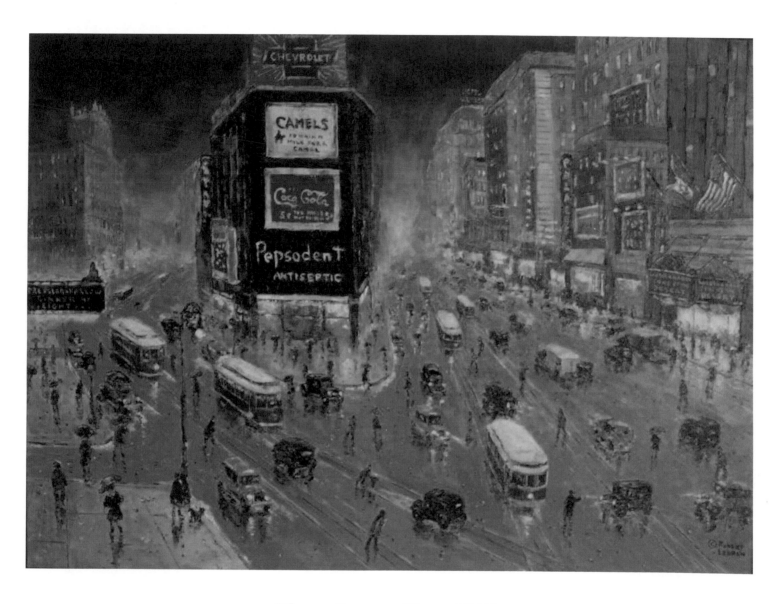

Times Square Circa 1933
Signed Lower Right
30" x 40"

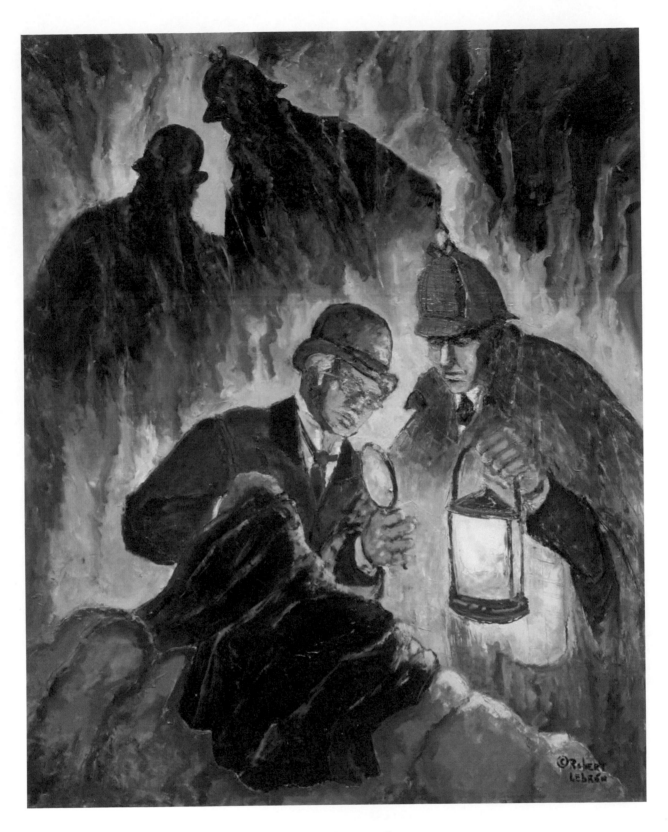

A Study in Scarlet
Signed Lower Right
30" x 24"

cleared customs, a swarm of Moroccans offered their services as guides. After a couple of days Robert soon ran out of sights to see and Tangier became boring and repetitious. Robert then took the two-hour ferry to Algeciras, a small port city in Spain close to Gibraltar; from there he headed to Malaga.

He rented a villa by the beach in Malaga and continued to paint the world around him while he searched for a comfortable technique of his own. He filled his days with observing the people and town, then painting a few hours each day. It was during this trip that Robert decided to only use the palette knife; he jokingly said he didn't have time to clean all the brushes he was carrying, especially while "plein air" painting. Robert received a communiqué from Mr. Landsberger; he wanted Robert to journey to Madrid and set up a potential source for importing Spanish art to America. Robert agreed and journeyed to Madrid where he met numerous Spanish artist and gallery owners, which allowed his view of art to expand.

Robert saved enough of the expenditure money from the Madrid trip that he could journey to Paris. It was almost a twenty-two hour train ride to Paris, but it was all the travel posters had depicted and then some—it was simply an architectural gem. He walked everywhere trying to absorb as much of Paris as possible to retain in his memory. During this journey it was too cold to sit out on the streets and sketch, so he took photos, hoping they would be useful for his paintings.

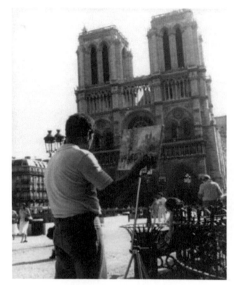

Robert Painting at the Notre Dame
Courtesy of Sandi Lebron

After returning to Malaga he prepared for his passage home, to New York City, on another Yugoslavian freighter. When he arrived home he began painting nearly every day. Robert's next art festival was in Atlantic City, where there were about one hundred artists strung along the boardwalk. During this show Robert's first big break came. An agent approached him, claiming to be connected with Vincent Price and the forthcoming art venture with Sears and Roebuck. Robert was skeptical, but the agent assured him that he would have his paintings in every Sears' outlet

in the country, Mr. Solomon, the agent, was a man of his word and his sales pitch—amazingly—came to pass. Robert only had to provide three finished paintings a week and they would provide good linen canvases delivered to his studio weekly. When Robert started painting for the Vincent Price Collection, he doubted that he could finish three works a week. After all, while in art school he could barely finish a small painting in a week. Robert however seemed enthusiastic about his career and readily agreed. He started his new venture and steadily improved; the palette knife becoming what he referred to as his sixth finger of his right hand. His subject matter was mostly based on photos and sketches from his Spanish sojourn. The one approach he never used was non-objective or total abstract; he had spent too many years drawing to abandon it for color splashes. The fact that he thought his color sense was the least of his accomplishments also added to his reluctance to venture into Modern Art.

Although Modern Art was not in his future, he never discarded his admiration for Lyonel Feininger's use of cubism and color. This respect led to clarity of mind while developing Robert's own technique, which would include cubism and impressionistic styles. He would use a more simplified palette by keeping the color in one basic warm or cool feeling. Even though his style would continue to evolve this was the beginning of a long and fruitful career. He often joked that he could paint himself into a corner and then had fun working himself out.

In the spring of 1962 Robert participated in another Greenwich Village Art Show. Rowe Langston, the block monitor who had seen Robert struggle through several shows, took one look at Robert's new work and proclaimed, "You got really good work this year." The art buyers attending the show seemed to agree and it was a financial success for Robert. Rowe Langston, a fellow artist who studied to be an architect, became a good friend and often guided Robert in the development of his technique for his cityscapes.

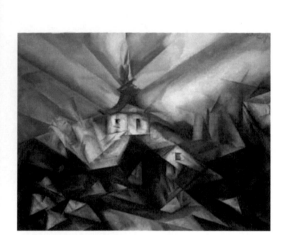

Lyonel Feininger
Benz VI - 1914

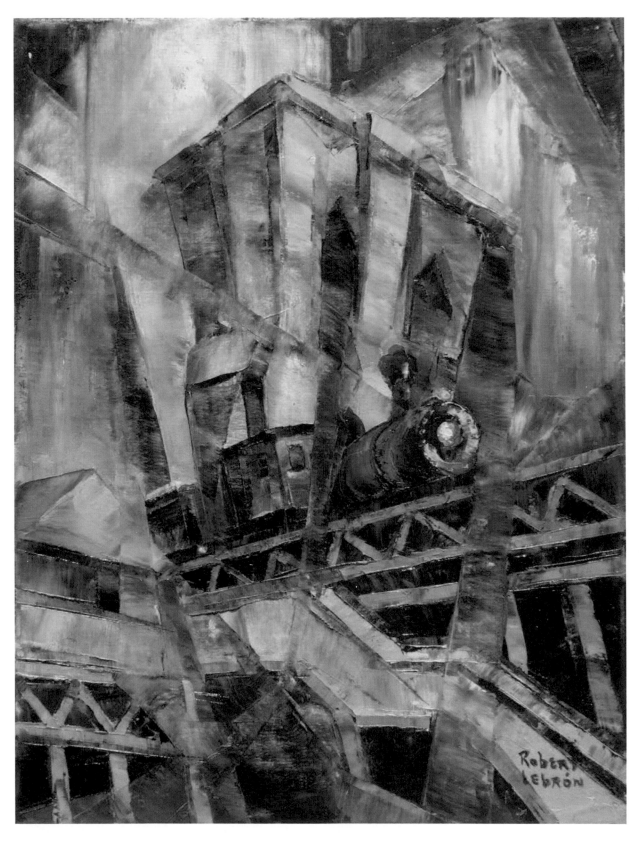

Brooklyn Bridge Cubistic
Signed Lower Right
16" x 12"

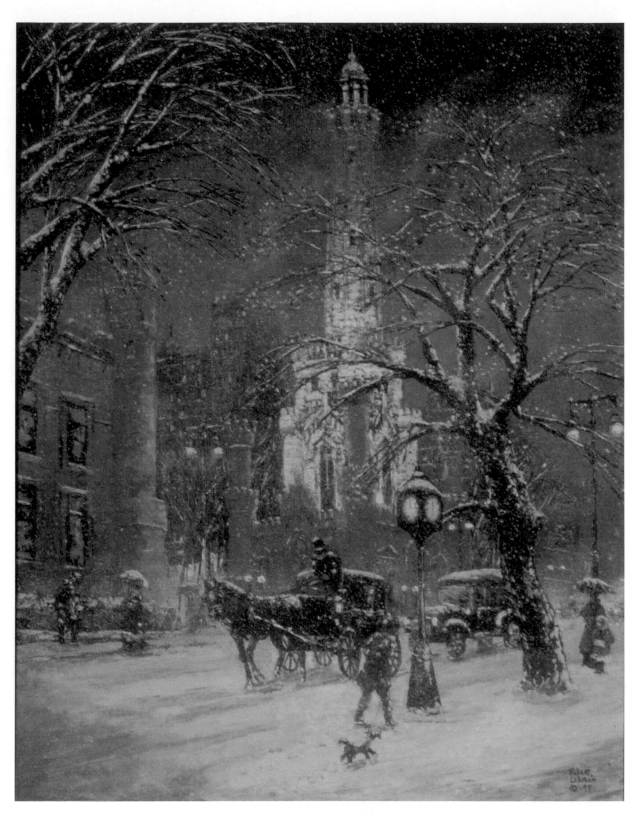

Chicago Water Tower
Signed Lower Right
30" x 24"

After multiple, successful, Greenwich Village Art Shows Robert thought it was time to return to Europe in 1965. His first stop was naturally Malaga, Spain where he remained for two weeks before continuing his European travels to Naples, Genoa, Florence, Rome, and finally London. In London Robert made sketches of landmarks such as Trafalgar Square, Westminster, Admiralty Arch, and the Thames River along with the Tower Bridge often commenting that the bustling river traffic made good subject matter.

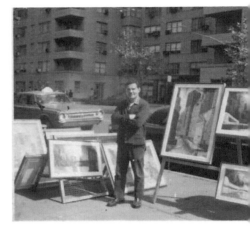

Robert Lebron
At the Greenwich Village Art Show

During 1966 Robert was contacted by Thanhardt-Burger, an Indiana art dealer to begin completing paintings for him to sell. Mr. Burger simply asked Robert "Where have you been hiding all these years?" When asking Robert for paintings, he would simply state four Chicagos, two Central Parks and three Covered Bridges. The compositions were always different and Robert's inventive eye and imagination were working full time. He became so busy he had to leave Sears and the Vincent Price collection. This year became so lucrative for Robert that he booked passage again to Europe but instead of traveling by freighter he purchased passage on the German ocean liner "Bremem".

After 4 months in Europe he returned to New York City and made his annual visit to the Museum of Modern Art. He went to some of his favorite permanent collections. Dali's "Persistence of Memory" with its dangling and twisted clocks still retained the need for more visual inspection for him. Several other artists with great rendering skills also drew his attention, but Picasso's "Guernica" always left Robert a bit puzzled. There was a lengthy explanation about the horrors and suffering of war to help the viewer understand the painting. Robert regularly joked by saying "glad it told me what I was looking at". He was never fond of works that couldn't explain themselves or its intent in twenty- five words or less.

Love was in the air after Roberts return to the states. He received a surprising phone call from an English girl he had met at a weekend party. Not that Robert remembered

her—or almost anyone else from the party—but he made a date to meet her at Coney Island. Her name was Diana Hartshorne. She was tall and willowy, and her clipped English accent sounded very high born. Robert was 38 years old and she was 22, working as a live in nanny with two very young girls in her charge. They began dating and after a few months she moved in with Robert. The summer of 1967 was approaching, and Robert decided to rent a car for two months, and tour the United States and Canada with Diana. When he returned to New York she made every effort to involve herself in his art career—at times she would also serve as his model. They settled into a working life that included Robert opening his own gallery at 14 5th Ave, New York City. Diana helped him at the Village Shows and Robert continued to paint all week long. Diana had started to talk to Robert about moving out of New York and suggested Santa Barbara. Robert agreed, but decided that he would return twice a year to the Village Shows. In 1972 Robert and Diana moved to Santa Barbara, California and were married November 29th of that same year.

Now living in Santa Barbara, Robert quickly took his work to the local galleries. They all seemed to focus on the subject matter only; they told him that eastern subjects would not sell in Santa Barbara. He requested that the galleries give his paintings a chance, but all he received was the same answer—no way will New York themes sell in Santa Barbara. It was surprising to him that a town with all the seeming sophistication of Santa Barbara should have such a provincial outlook on art. It was suggested that he join the local beach outdoor art show, where he might sell an occasional piece to some eastern tourist.

Robert's first Sunday at the show was met with negativity from the other exhibitors. Some tried giving him helpful hints, and others smiled tolerantly at his display, while shaking their heads at the lack of potential sales for his work. By midday everyone was set for the large Sunday crowds. The afternoon went quickly and interest in Robert's work was shared by much of the viewing public.

Invitation to Robert's Gallery
1968 sketch of 5th Ave Gallery

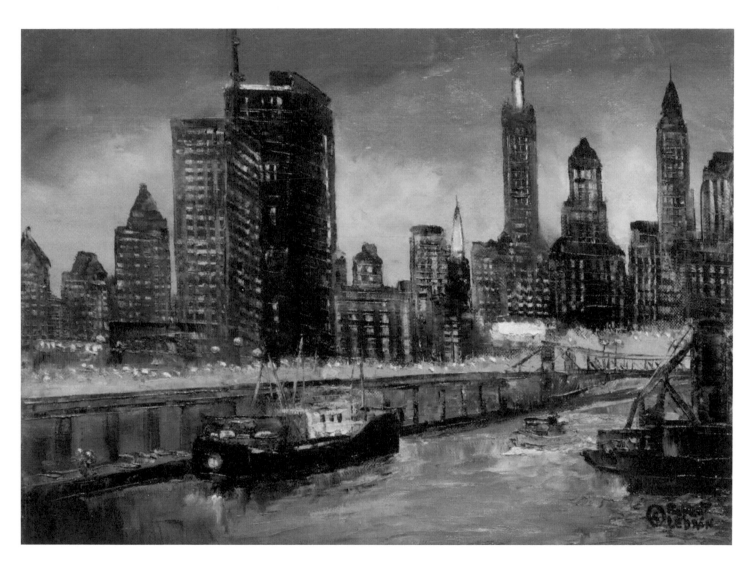

Chicago Skyline
Signed Lower Right
12" x 16"

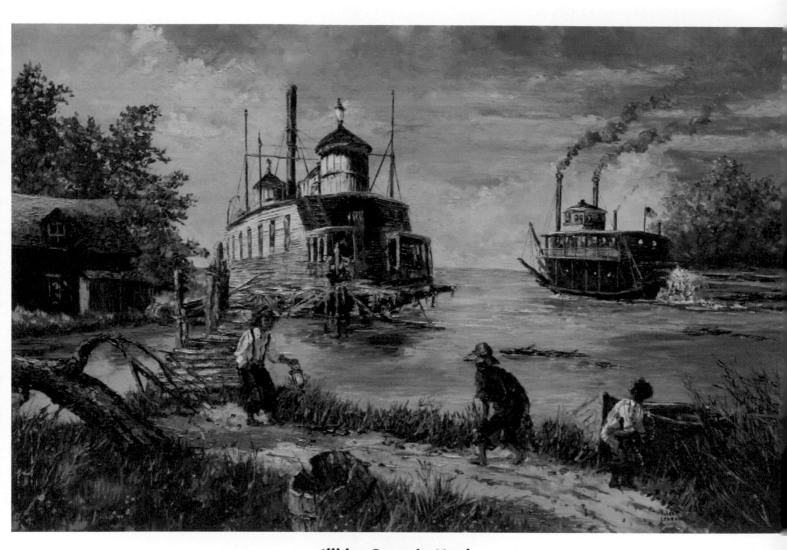

I'll be Captain Huck
Signed Lower Right
24" x 36"

Robert sold multiple paintings and the amazed stares of his fellow artist were great for Robert. He was, frankly, the most surprised person at the beach show that afternoon. He sold six paintings and his expenses for the entire month were covered. The following Sundays continued with equal success. On occasion an exhibitor would ask how he handled the sales, thinking that it was all a sales pitch. They couldn't grasp the fact that a good painting would sell on its merit, not just on the location or theme of the painting.

At the occasional Sunday art show one of Roberts's fellow exhibitors would wander in and always catch his attention. Eventually he summoned enough courage to ask her name. "Sue Ann Faulkner," she replied, "but everyone calls me Sandi." As their friendship grew, Robert noticed that she displayed knowledge of famous artists. Her knowledge of Johannes Vermeer, Robert's favorite painter, stunned him the most, since most of the beach artists had very little art background, if any at all. Sandi painted western motifs on leather and seemed to sell them quite well. One day she asked Robert what book(s) he would recommend for drawing; he suggested George B. Bridgman's beautifully structured books on drawing the human face and body. The following Sunday Robert brought her his copy of Bridgman's book and a book containing paintings by the old masters.

Sketch of Sandi Lebron
Ink on Paper
8 ¼" x 11 ½"

This student-mentor relationship became unmanageable and morphed into a romance. This love affair remained a secret until 1979, when Robert's wife eventually found out. Robert was unaffected by Diana discovering this secret. He found in Sandi a kindred spirit and a person who understood and lived for art, just as he did. Robert willingly gave full possession of the house and almost everything else he owned to Diana. Robert eventually divorced Diana and married Sandi in 1980.

Robert was 52 and Sandi 31, a 21-year difference; his keen eye for younger woman was self-evident. He moved in with Sandi and her son Aaron after their marriage. Robert had to start all over after giving everything to Diana, but he

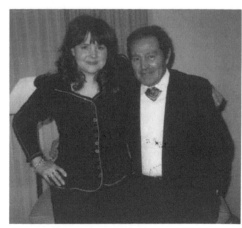

Robert and Sandi Lebron
Courtesy of Sandi Lebron

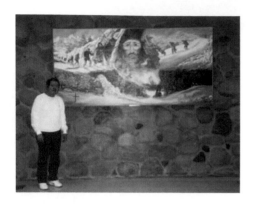

Robert with his Donner Party Painting
At the Emigrant trail Museum

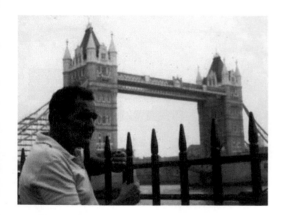

Robert at the Tower Bridge
Courtesy of Sandi Lebron

didn't care, thanks to his sales at the Greenwich Village Art Show. These sales continued to rise with each passing exhibit and was simply too lucrative for him to give up. He was also commissioned in the early 80's to complete a series of paintings depicting the Donner Party. These paintings were completed for the Emigrant Trail Museum in Truckee, California and can still be seen on display.

Back at the beach show everyone assured the two artists that Carmel at the time was the art mecca of California. Robert decided to drive up to Carmel and bought along some of his paintings. He had very little expectancy of any real success. Once there a gallery owner William Lindsey, of Lindsey Gallery, took a few glances at his work and agreed to exhibit them. Within a week the gallery sold three of Robert's paintings and was requesting more of his Paris street scenes. Now, more than ever, Robert began concentrating on his Parisian scenes.

It was wonderful to no longer be dependent on any organized art show, but the bright spot of the Santa Barbara Beach Show was the contacts made with many people who were professionals and celebrities. Among them were a Los Angeles County Superior Court Judge, Earl Riley, and his lawyer wife, Susan Canter; movie star/director Ron Howard and comedian Carol Burnett were also among Robert's collectors. The time at the Beach Show allowed Robert to accumulate a wonderful mailing list, which led Robert and Sandi to host their own exhibition at a large beach front hotel, The Sheraton on 1111 Cabrillo Blvd Santa Barbara – now it's the Hyatt Santa Barbara. They continued to host this exhibit every February for the next decade.

Robert's newfound freedom allowed him and Sandi to travel to Europe often. Paris and London had once again given Robert new vistas. The variety of the two cities seemed enough to keep him painting for years to come. However he expanded to Austria, and the French and English countryside as well. Spain remained a favorite with truly marvelous scenes as his trip to Granada

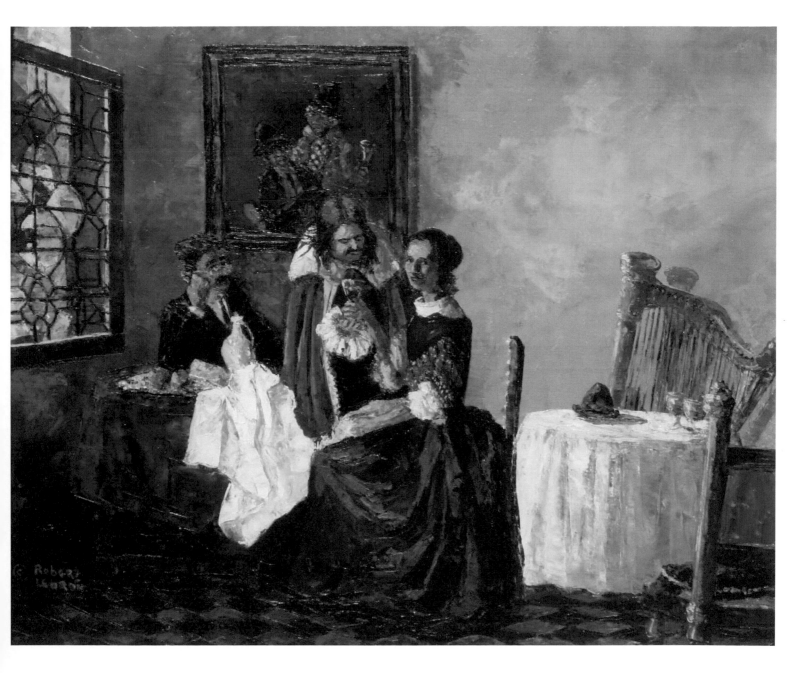

Vermeer's Girl with the Wine Glass and the Marx Brothers
Signed Lower Left
20" x 24"
Collection of Albert L Rolon

had proven. The massive Alhambra was filled with wondrous palaces and old turrets that stretched out over hundreds of acres filled with beautiful gardens and orange trees that gave Robert inspiration for numerous paintings.

While visiting Roy McMahon, a friend and collector in northern Ireland, Roy's wife, a school teacher, persuaded Robert to have the children in her third grade class draw Mickey Mouse under his demonstrating direction. This sparked a desire in Robert to start teaching children and when Robert returned to Santa Barbara he did just that. Until the last year of Robert Lebrón's life he taught kids drawing, whenever or wherever he was asked.

While in Europe Robert visited paintings completed by his favorite painter, Johannes Vermeer. His admiration for Vermeer's work led Robert to complete a series of paintings depicting Vermeer's genre scenes, which included classic movie actors. Some examples include the combining of Vermeer's Milkmaid with Humphrey Bogart, The Girl with the Wine Glass and the Marx Brothers, and Woman with a Lute and Charlie Chaplin, among others.

After 22 years of marriage Robert and Sandi divorced due to irreconcilable differences. After their divorce Robert, at the age of 74, moved to Florida to be closer to his younger brother Paul. While living in central Florida Robert continued to paint and teach at a local gallery. During his free time he worked on his first fictional novel, entitled "The Da Vinci-Picasso Dialogue," which was published in 2012. This was a witty story about the skill versus the promotional aspects of art.

Even after their separation Robert and Sandi remained close friends, and in 2012 Sandi relocated to central Florida to be with Robert. Unfortunately this was a short-lived reunion; Robert fell ill in August 2013. He was hospitalized for pneumonia, but even illness could not keep him from his passion. While in the hospital he requested that Sandi bring him his sketchbook. However Robert never recovered from his illness and passed away on August 31, 2013 at the age of 85.

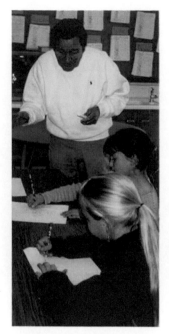

Robert Teaching Children Drawing
Courtesy of Sandi Lebron

Robert and Vermeer Painting
Vermeer Exhibition in the Netherlands

The Art of Robert Lebrón

A Sketch by Robert Lebron - 1999

New York City

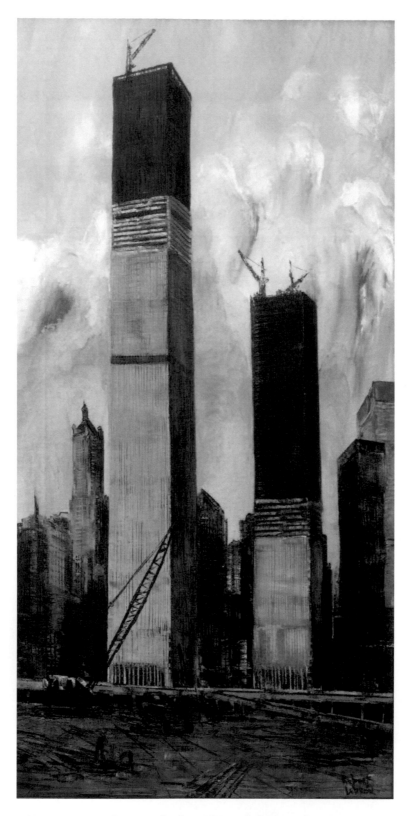

Construction of the World Trade Center
30" x 15" 1970
Collection of Angelo and Dawn Mazzola

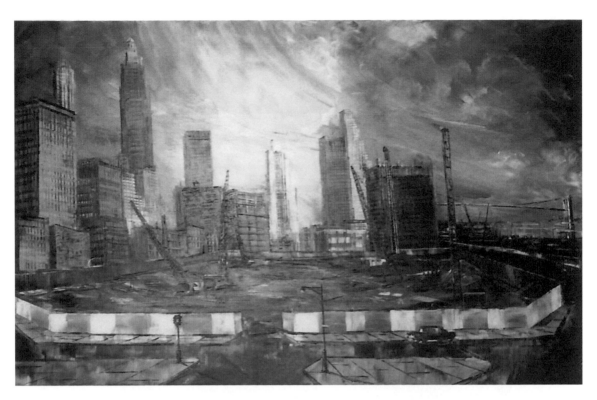

World Trade Center Construction
24" x 30" Ca. 1967

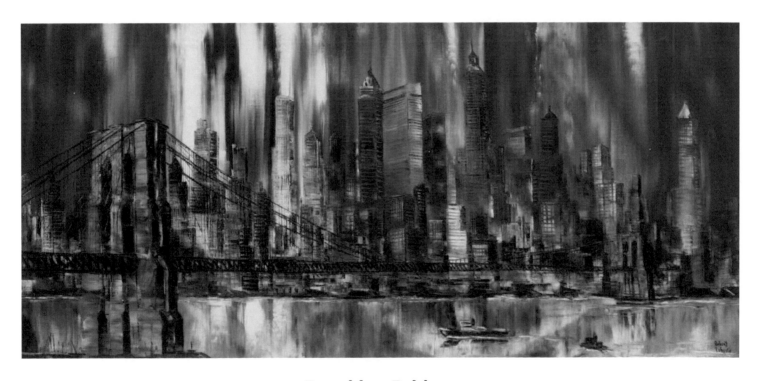

Brooklyn Bridge
24" x 48" Ca. 1969
Collection of Albert L. Rolon

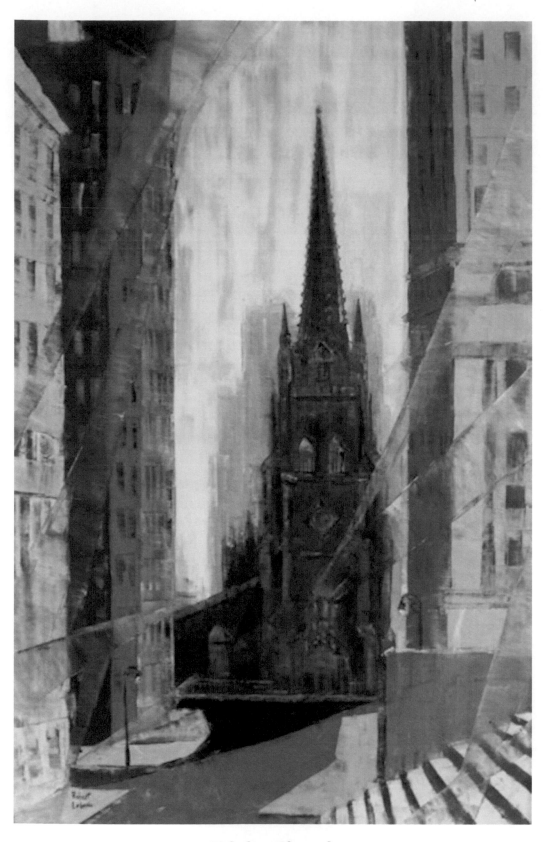

Trinity Church
36" x 24" Ca. 1960
Collection of David Castleberry

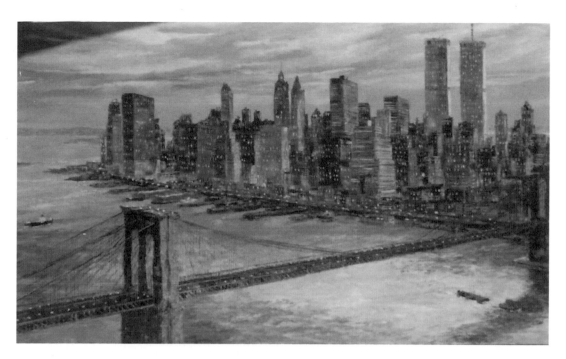

Brooklyn Bridge, New York Skyline
24" x 36" Ca. 1973

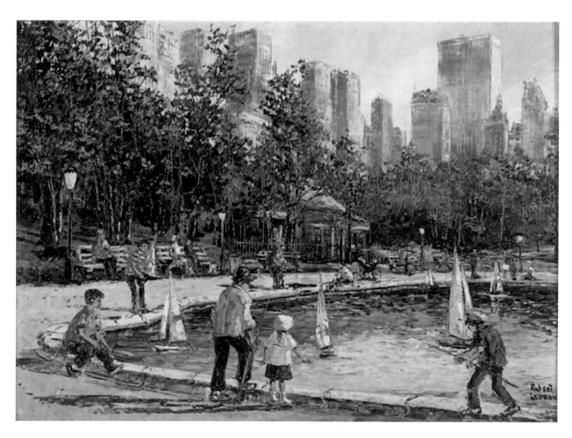

Boat Pond in Central Park
18" x 24" Ca. 1970

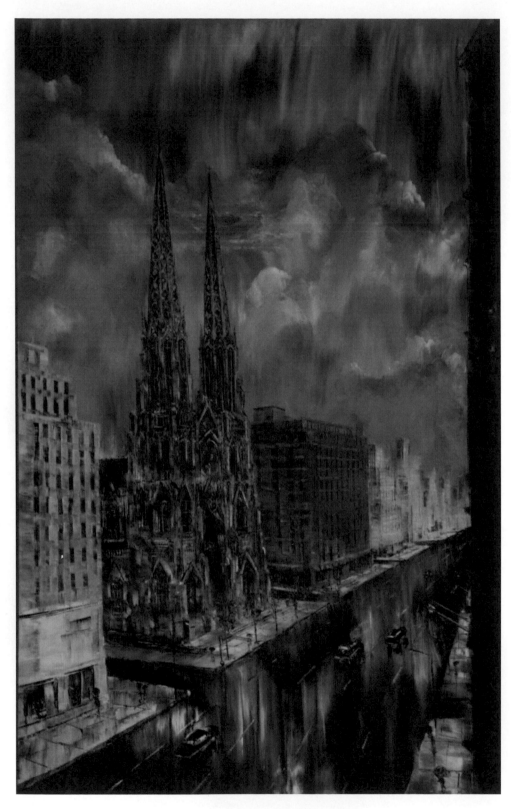

St. Patrick's Cathedral
48" x 30" Ca. 1970
Collection of Don Somppi and Jill Warren

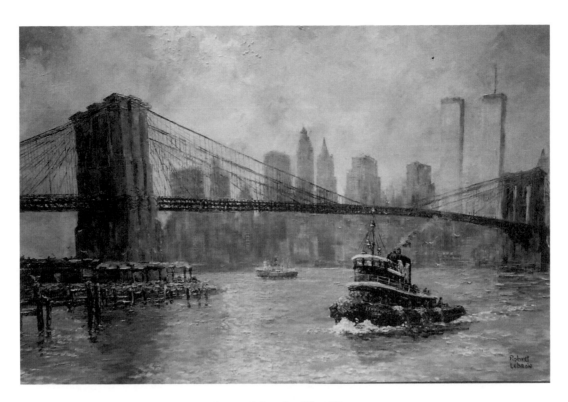

New York Skyline
24" x 36" Ca. 1975

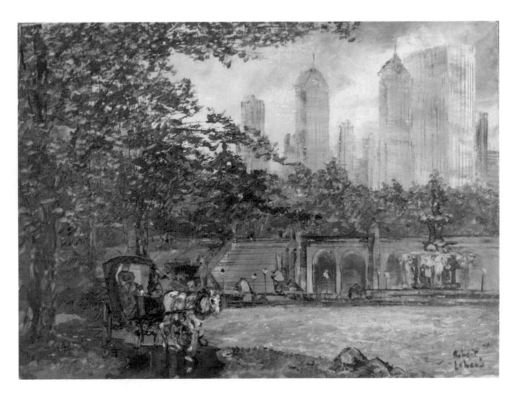

Bethesda Fountain Central Park
9" x 12" 1975
Collection of Jeffery Bisset

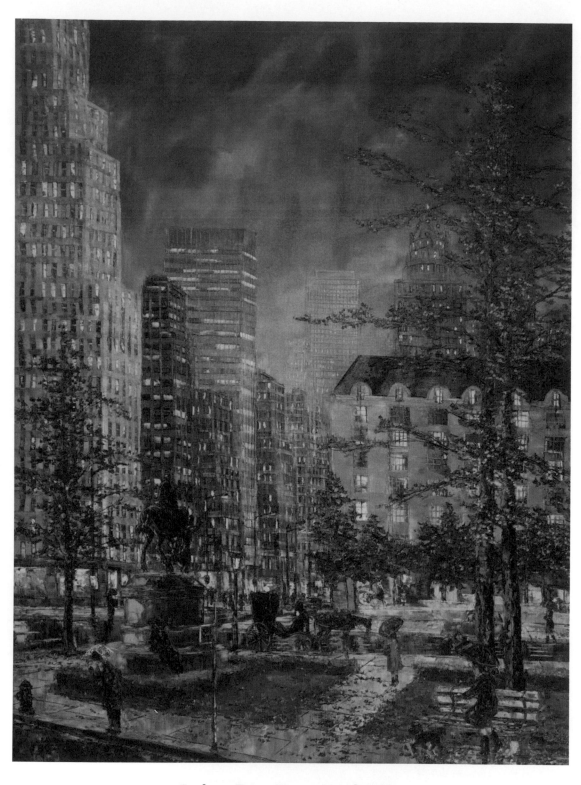

Rainy Day New York City
40" x 30" Ca. 1978
Collection of Linda Gorham

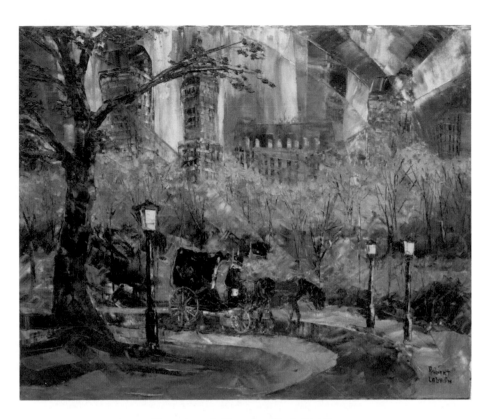

Central Park Cubistic
20" x24" 1978
Collection of Albert L Rolon

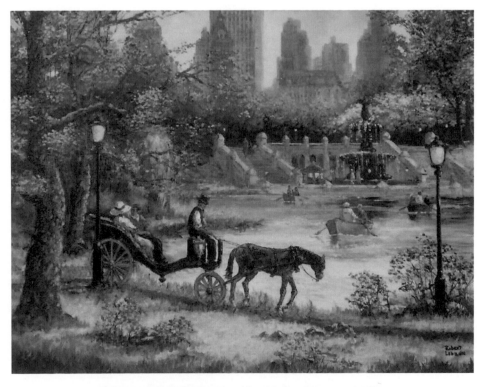

Central Park Bethesda Fountain
20" x 24" Ca. 1980

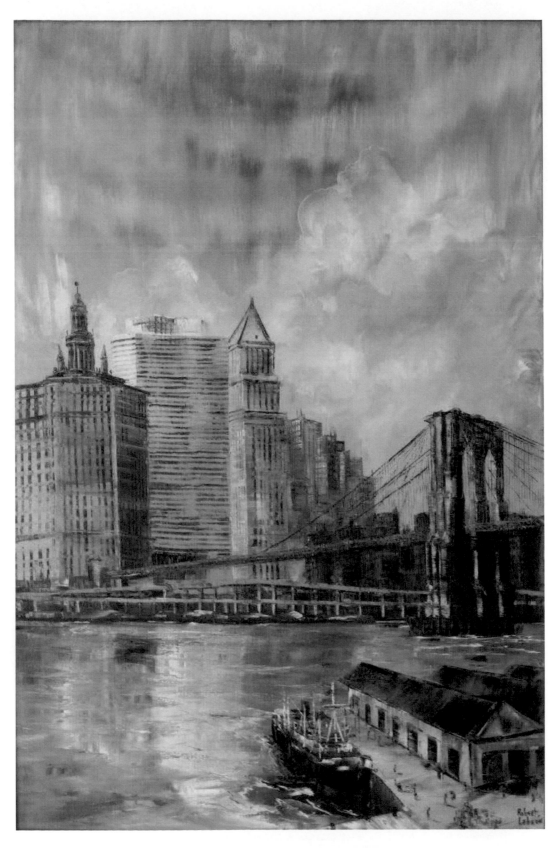

New York City Brooklyn Bridge
36" x 24" Ca. 1975
Collection of Colleen Norman

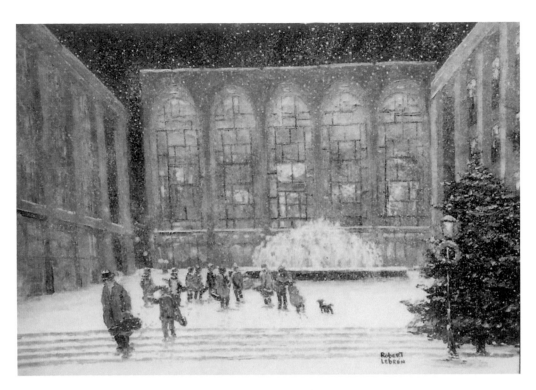

Lincoln Center at Christmas
24" x 36" Ca. 1985

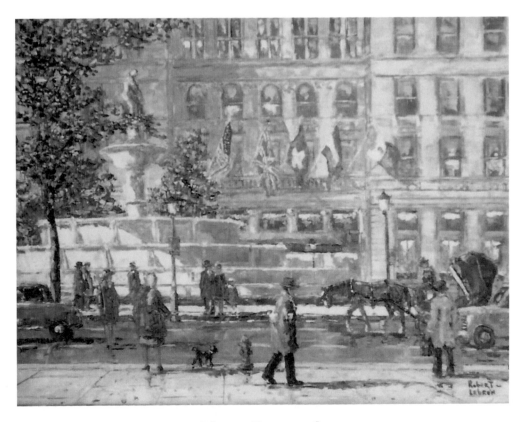

Plaza Fountain
20" x 24" Ca. 1987

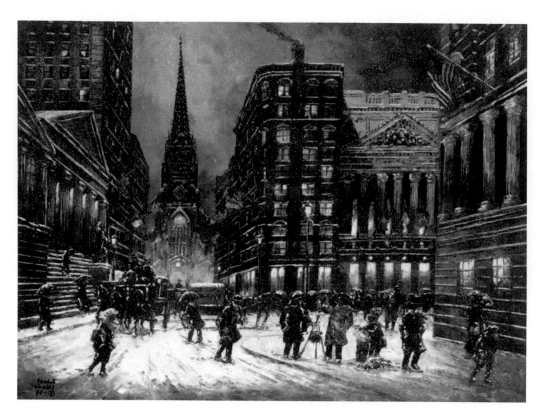

Wall Street in Winter
30" x 40" 1999

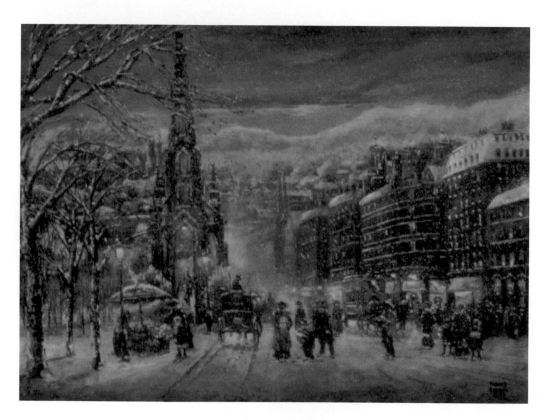

Trinity Church
24" x 36" Ca. 1993

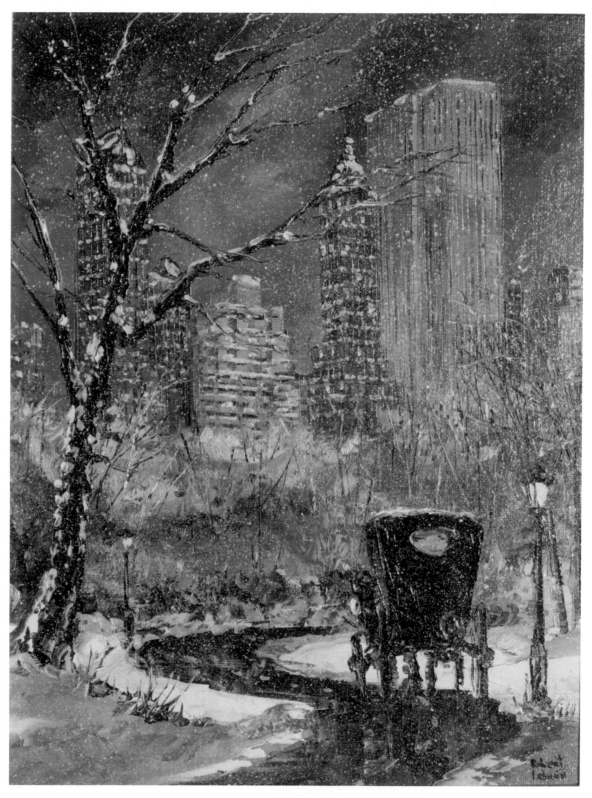

Central Park Winter Night
12" x 9" 1982
Collection of Albert L Rolon

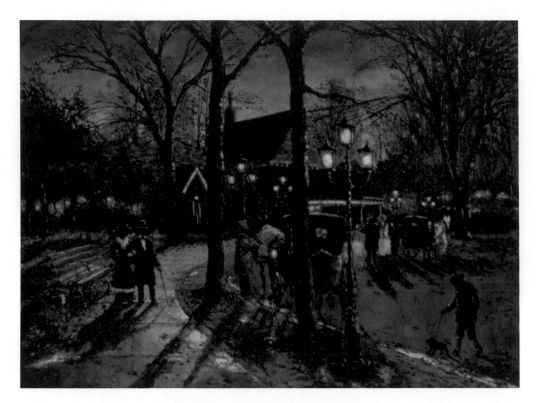

Tavern on the Green
20" x 24" Ca. 1990

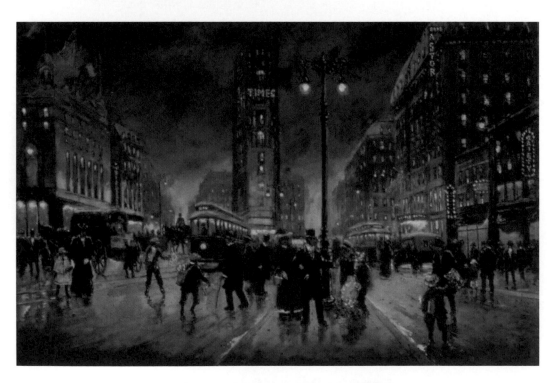

Times Square Circa 1890
24" x 36" 1997

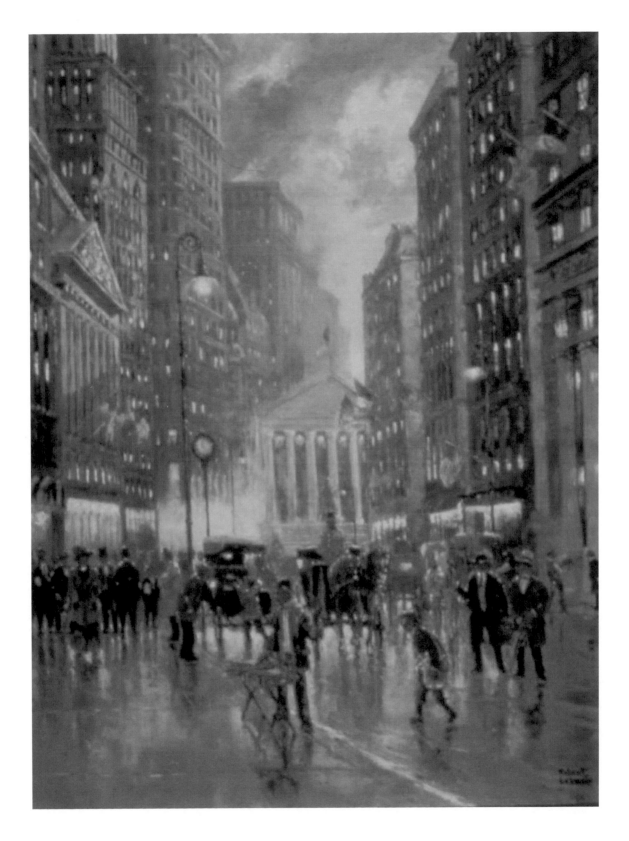

Wall Street
24" x 18" Ca. 1990

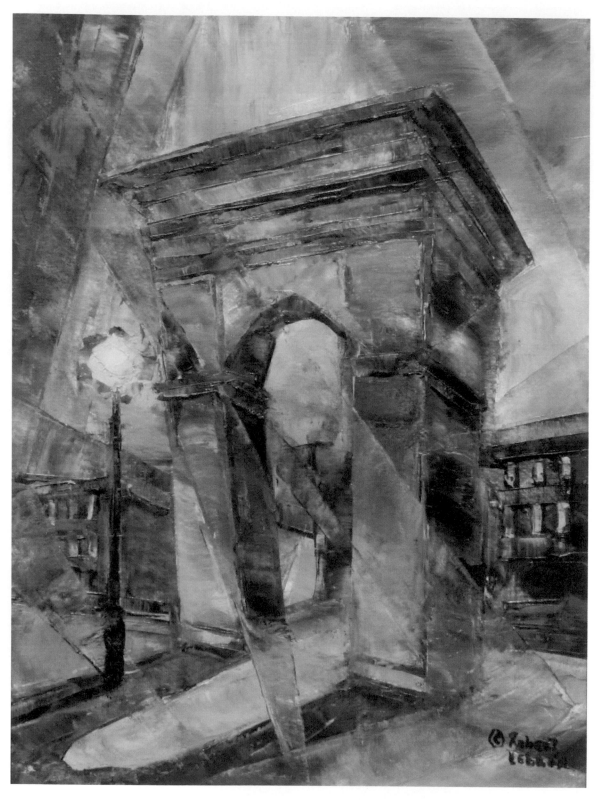

Washington Square Park Cubistic
16" x12" Ca. 1998
Collection of Albert L Rolon

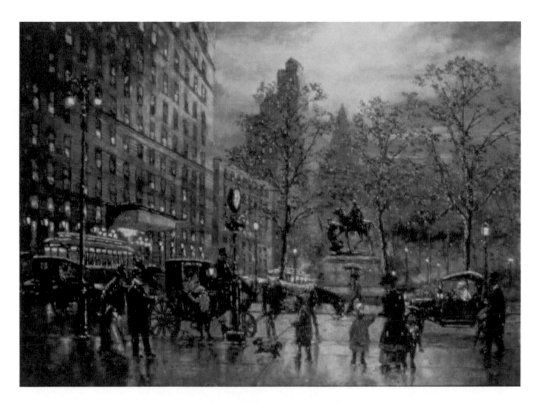

The Plaza Hotel
30" x 40" Ca. 1990

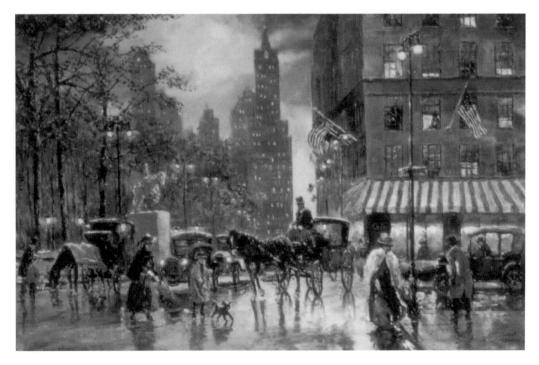

St. Moritz Hotel
24" x 36" Ca. 1995

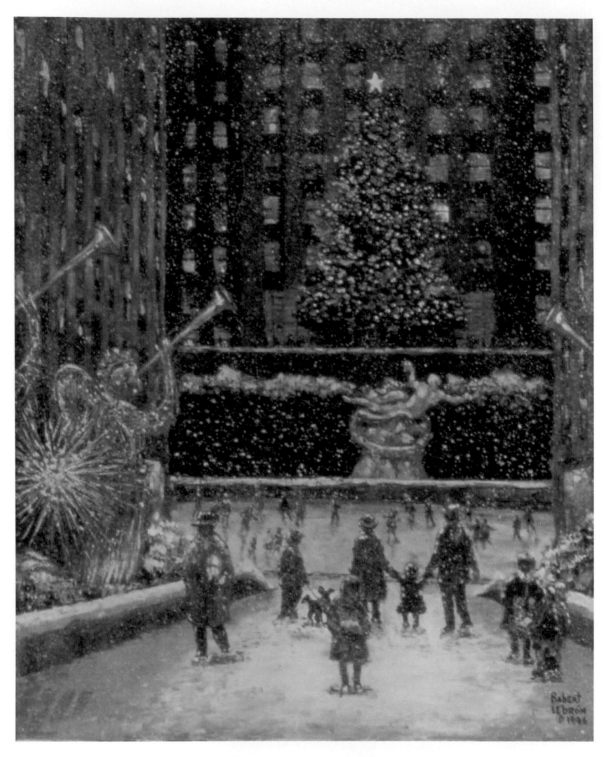

Rockefeller Center at Christmas
24" x 18" 1996

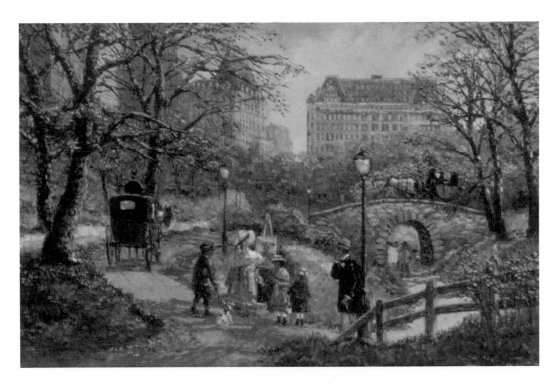

Central Park
24" x 36" Ca. 1992

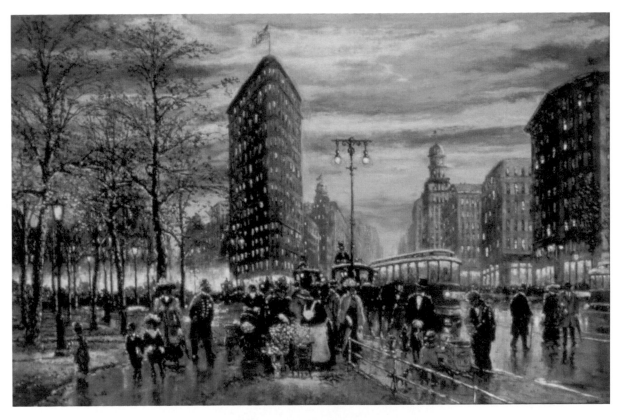

Flat Iron Building
40" x 60" Ca. 1995

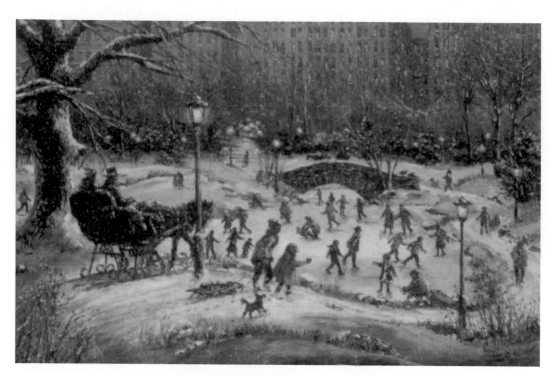

Central Park Ice Skating
24" x36" 1996

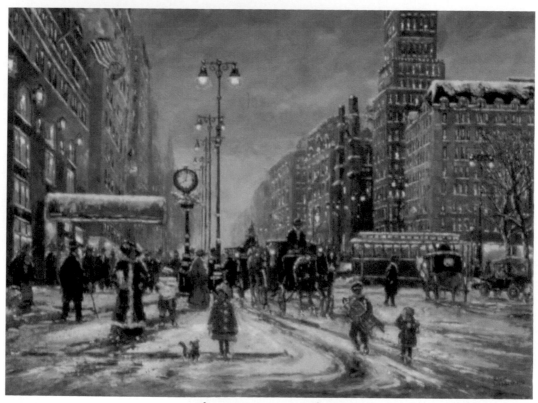

59th Street at 5th Ave
24" x 30" 1996

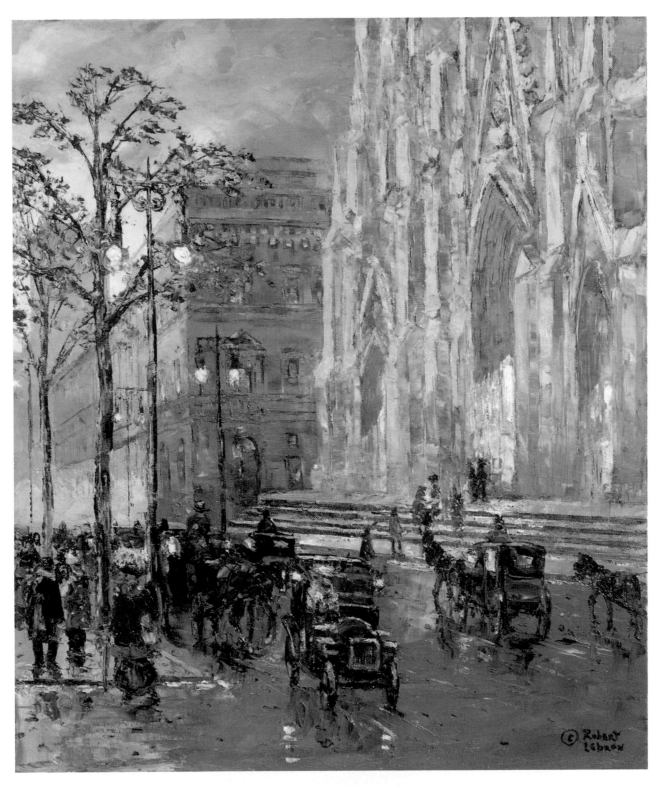

St. Patrick's Cathedral
24" x 20" Ca. 1999

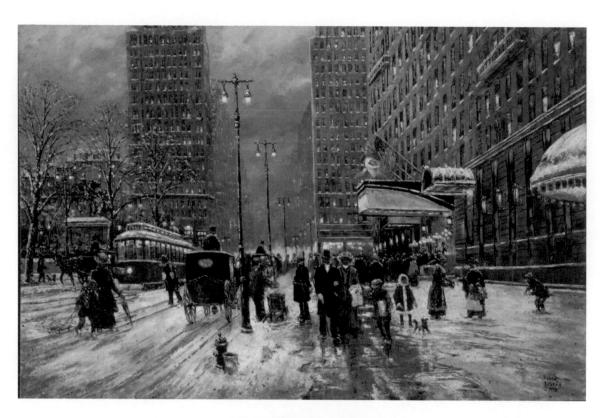

The Plaza Hotel
24" x 36" Ca. 1997

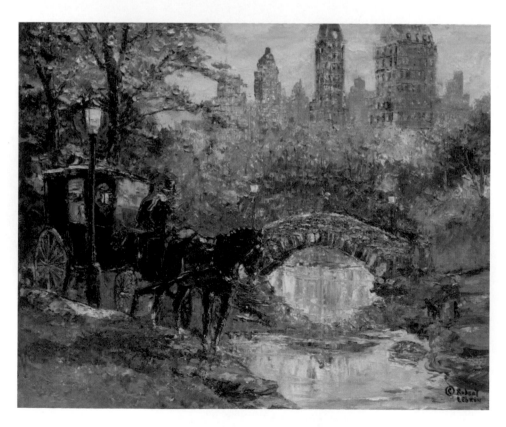

Central Park in Autumn
20" x 24" Ca. 2000

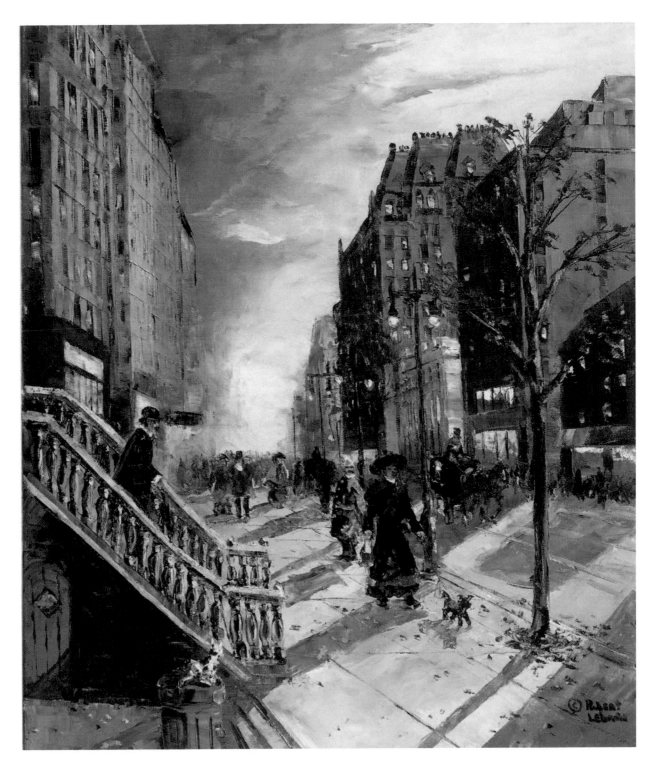

Lady with a Red Scarf
24" x 20" Ca. 2000

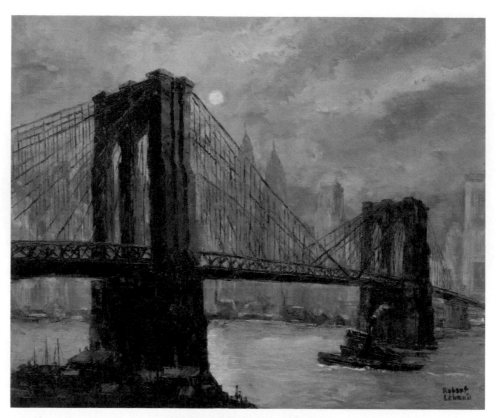

Brooklyn Bridge
20" x 24" Ca. 1998

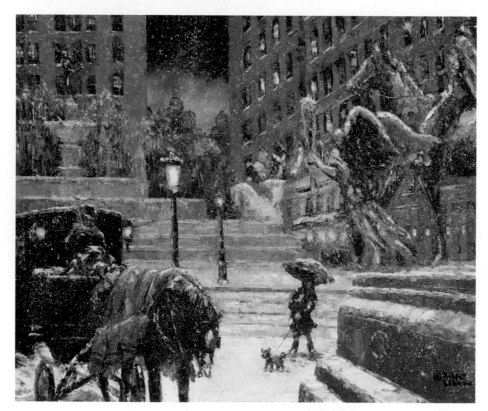

Snow Storm by the Plaza
20" x 24" Ca. 2000

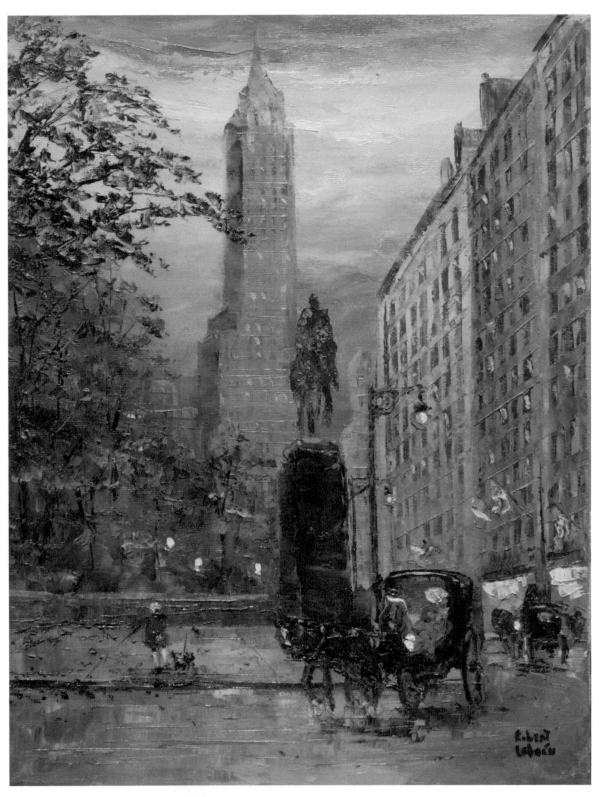

59th Street and Central Park
16" x 12" Ca. 2002

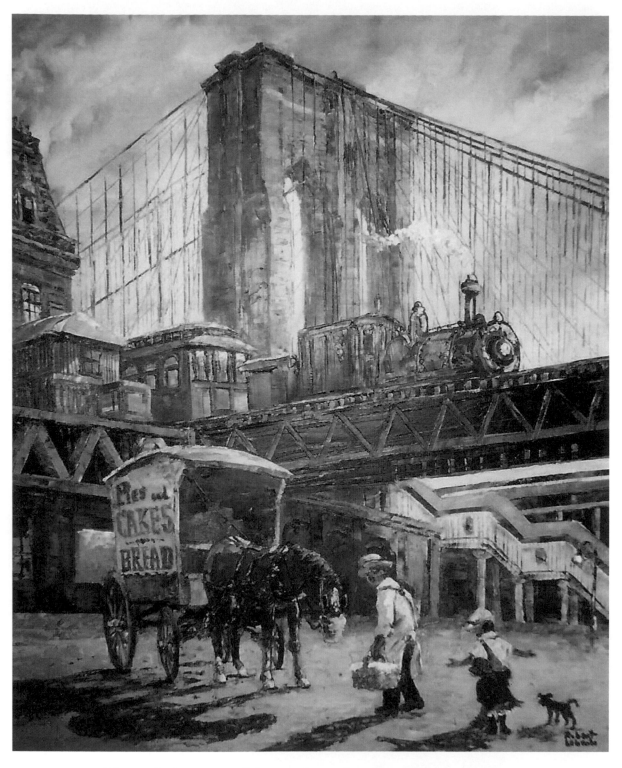

Pies, Cakes, and Bread at the Brooklyn Bridge
24" x 18" Ca. 1998

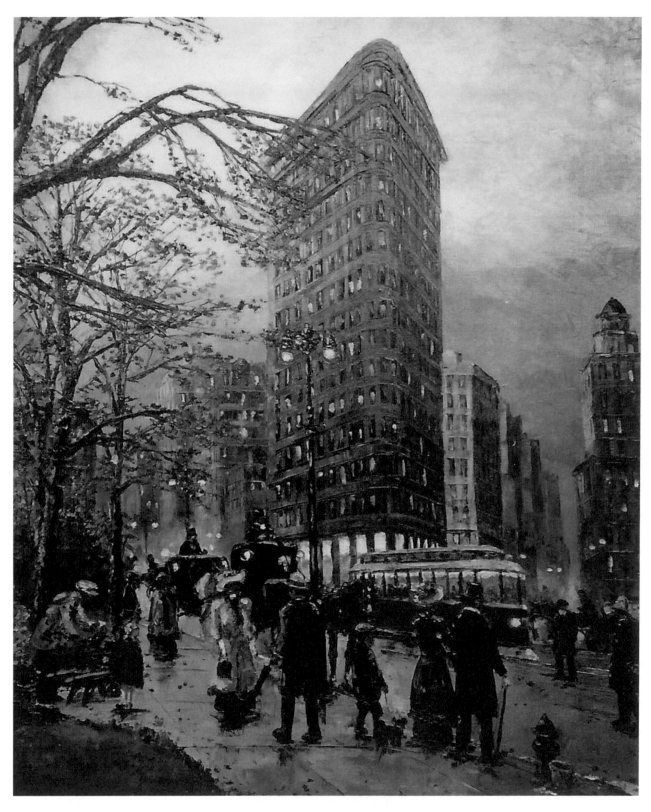

Flat Iron Building
36" x 24" Ca. 2004
Private Collection

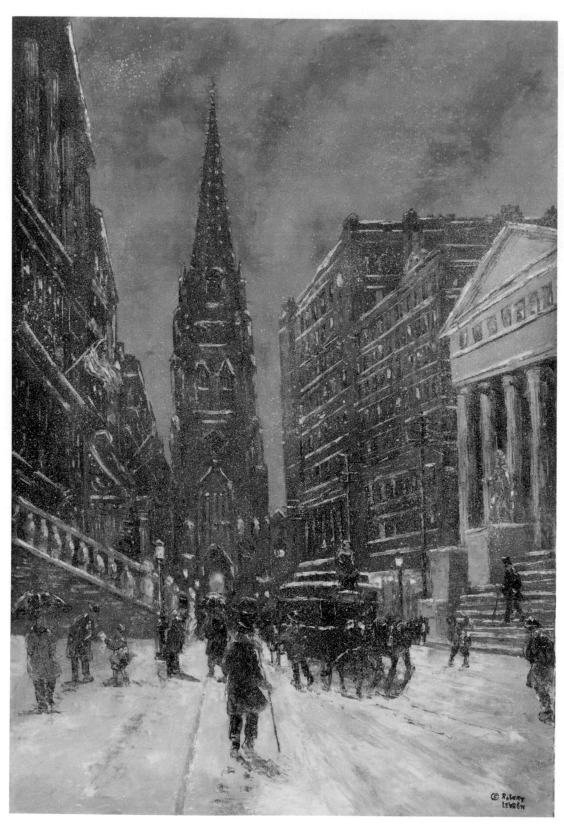

Wall Street in the Snow
36" x 24" Ca. 2005

Paris

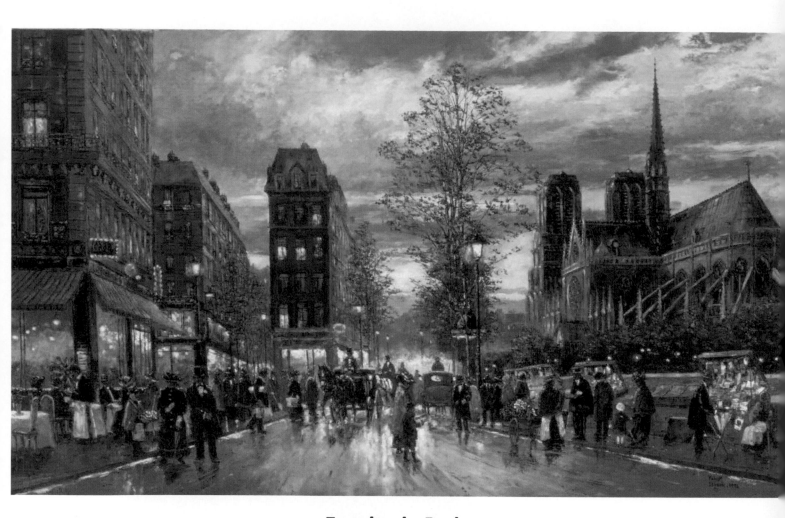

Evening in Paris
40" x 68" Ca. 1996

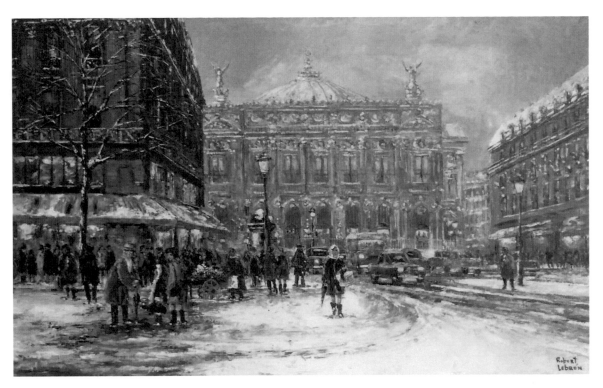

Paris Opera House in Snow

24" x 36" Ca. 1988

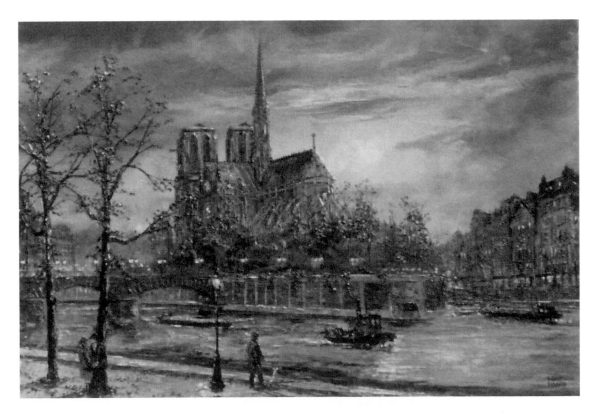

Notre Dame and the Seine River

24" x 36" Ca. 1989

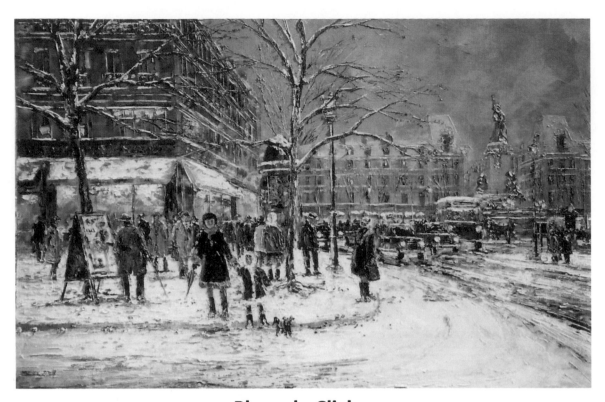

Place de Clichy

24" x36" Ca. 1988

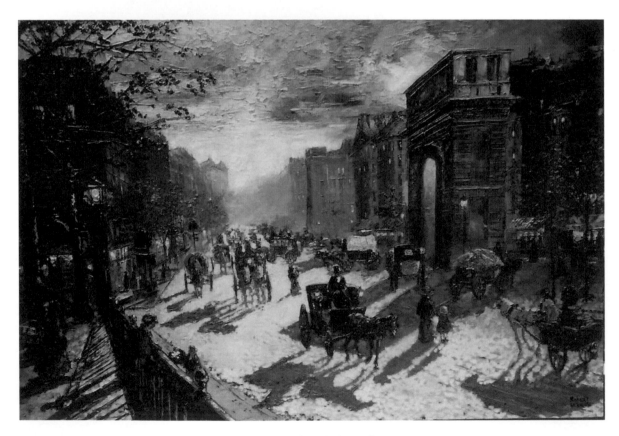

Porte St. Martin

18" x 24" Ca. 1989

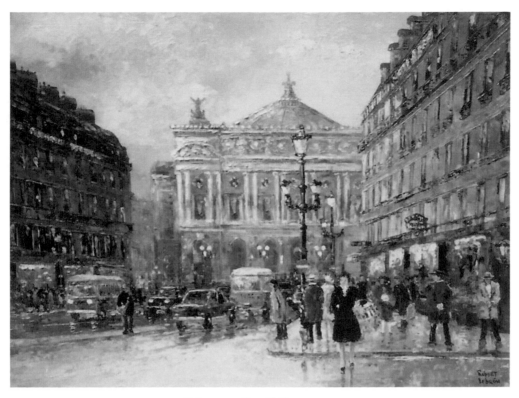

Place de l'Opera

20" x 24" Ca. 1989

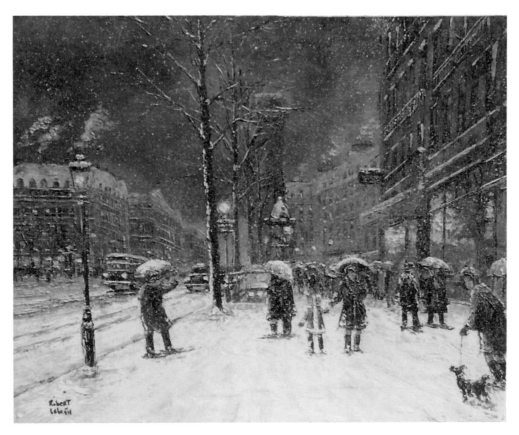

Porte St. Denis Winter

20" x 24" Ca. 1989

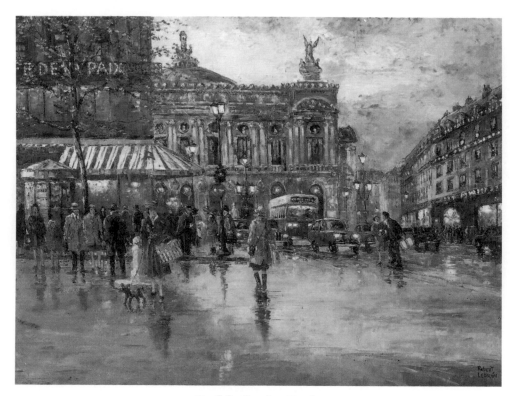

Café de la Paix

18" x 24" Ca. 1988

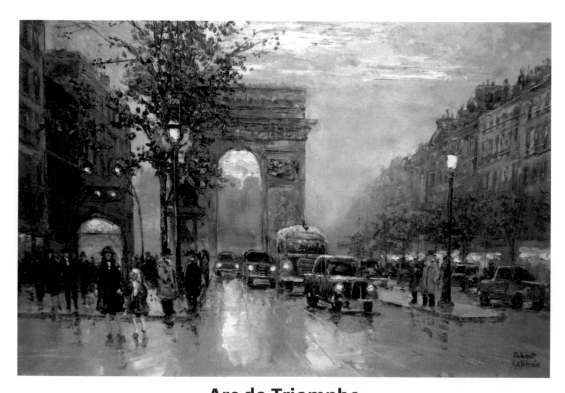

Arc de Triomphe

18" x 24" Ca. 1989

Collection of John and Jean Snyder

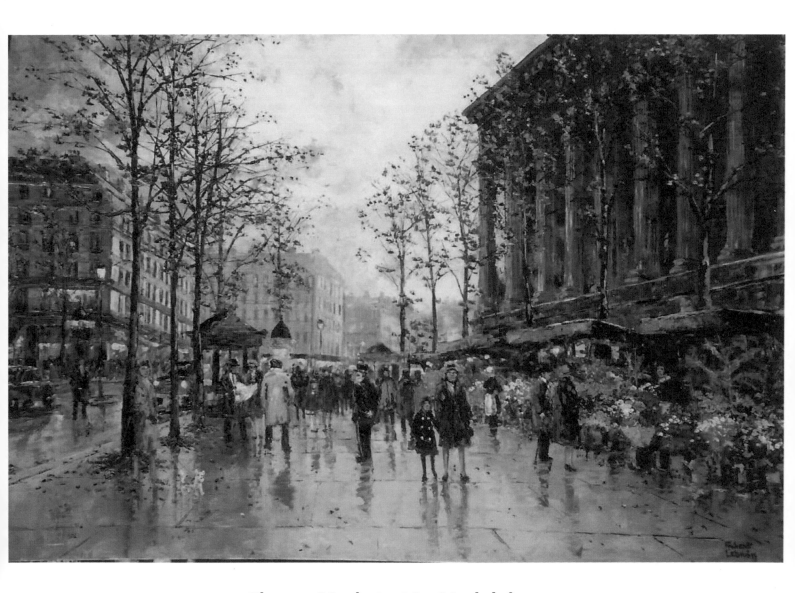

Flower Market at La Madeleine

18" x 24" Ca. 1990

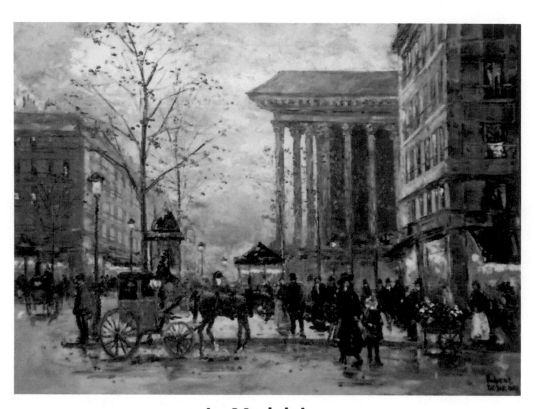

La Madeleine

16" x 20" Ca. 1992

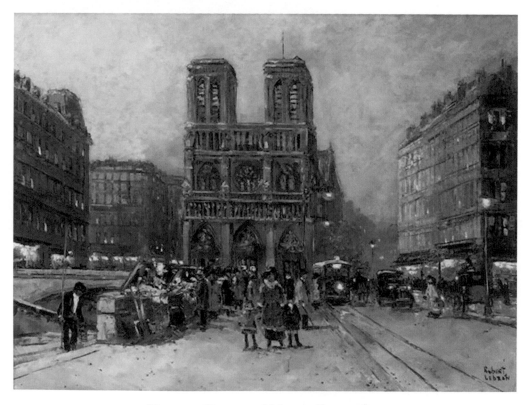

Notre Dame West Façade

20" x 24" Ca. 1991

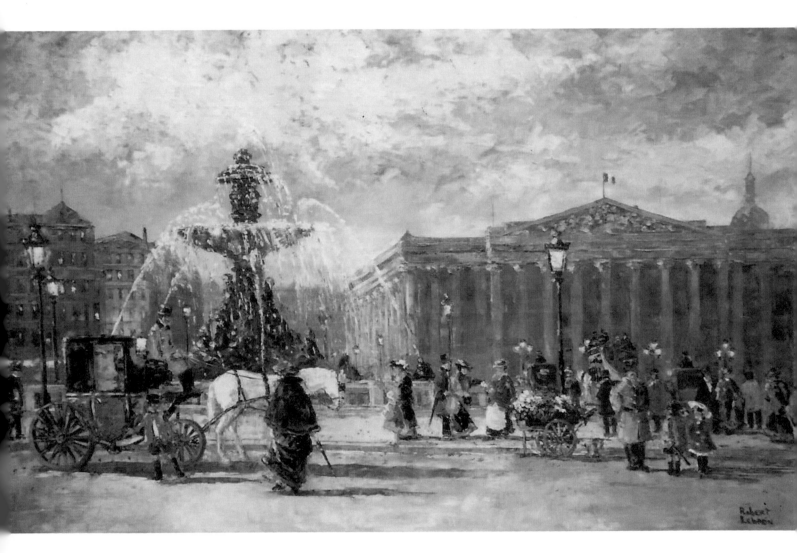

Place de la Concorde

24" x 36" Ca. 1994

Private Collection

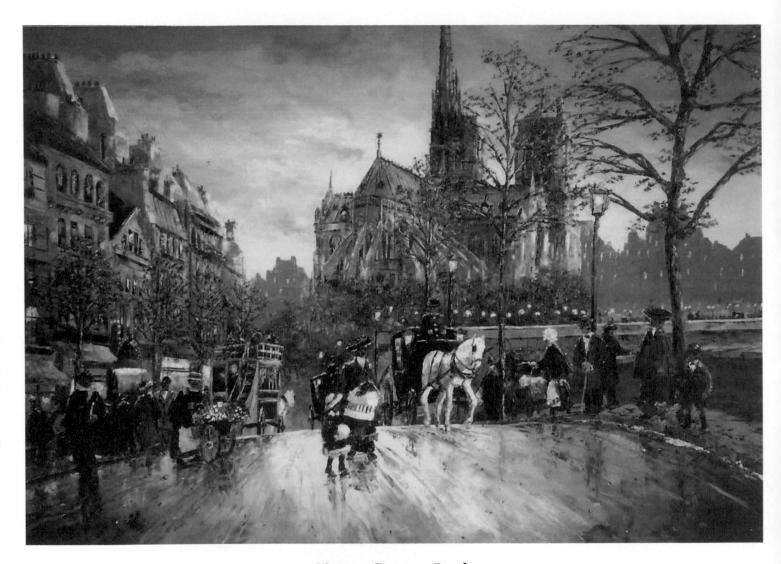

Notre Dame Paris

36" x 48" *Ca. 1993*

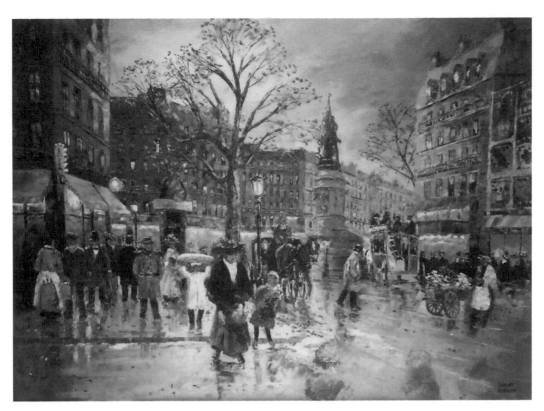

Place de Clichy

18" x 24" Ca. 1991

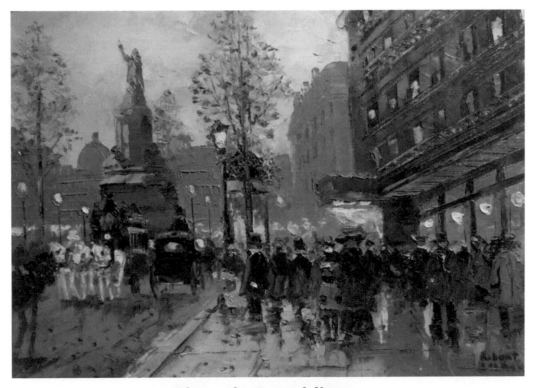

Place de Republique

12" x 16" Ca. 1992

Collection of John and Jean Snyder

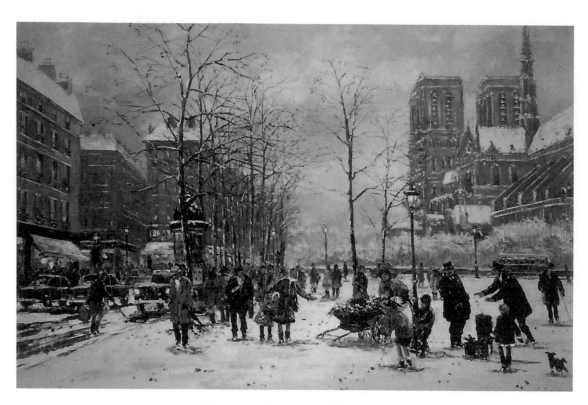

Notre Dame Winter

18" x 24" Ca. 1994

Private Collection

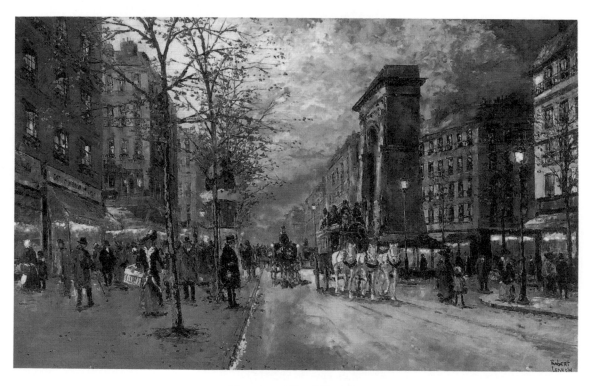

Porte St. Denis

18" x 24" Ca. 1994

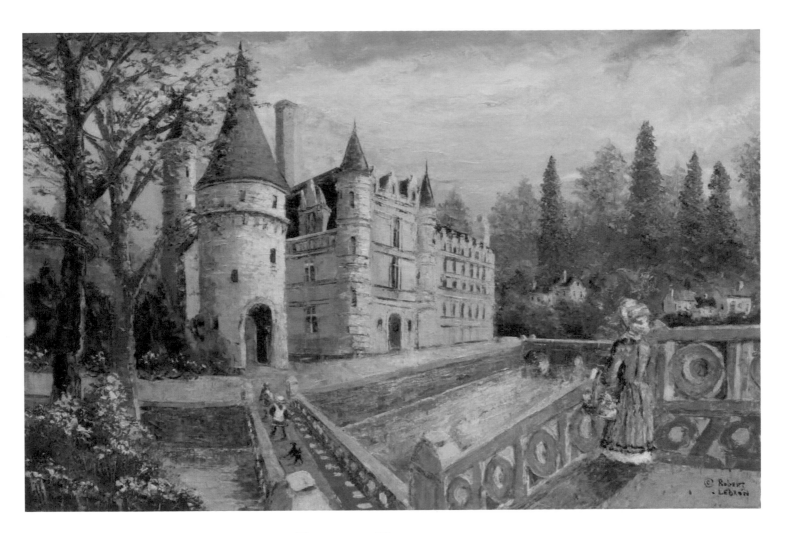

Chateau Chenonceau

24" x 36" Ca. 1999

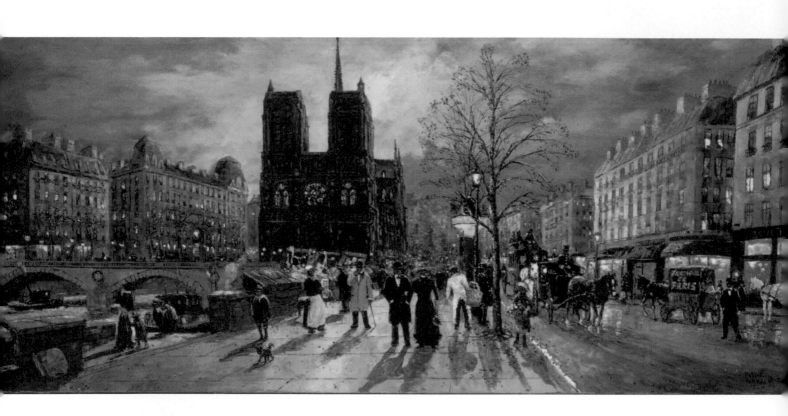

Evening Along the Seine

34" x 75" Ca. 1997

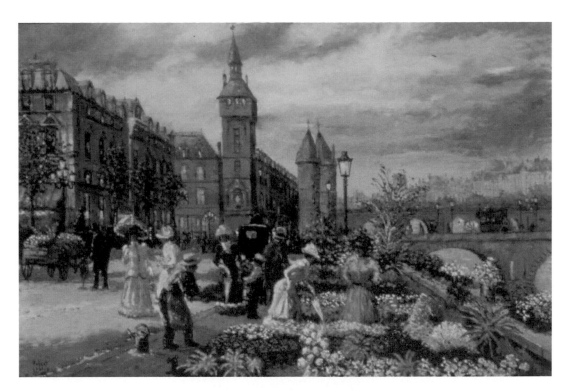

Paris Flower Market

24" x 36" Ca. 1999

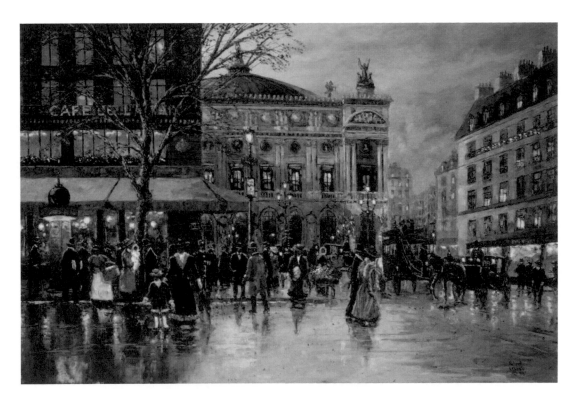

Paris Opera House

20" x 24" Ca. 1998

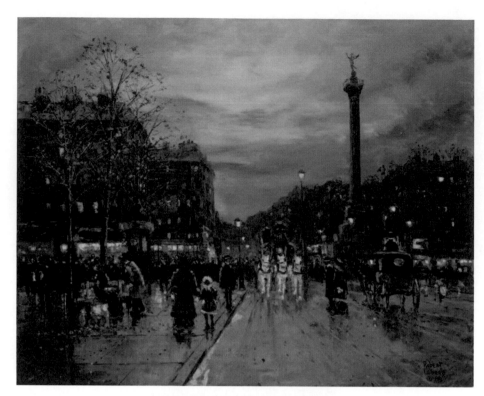

Place de la Bastille

20" x 24" Ca. 1998

Private Collection

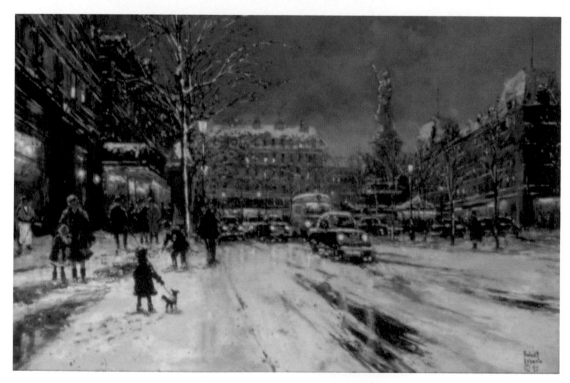

Place de la Republique

18" x 24" Ca. 1997

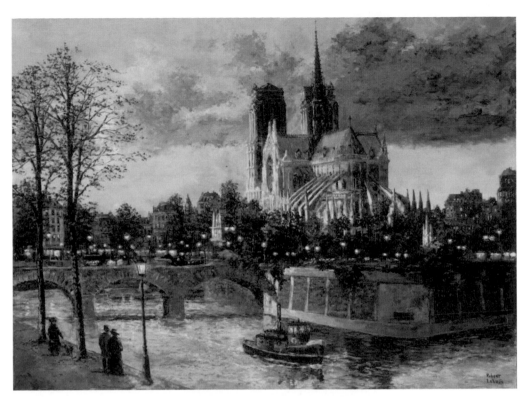

L' Eglise Notre Dame

36" x 48" Ca. 1999

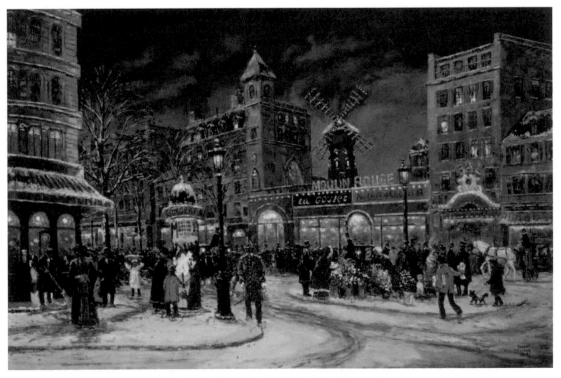

Moulin Rouge in Winter

24" x 36" Ca. 1997

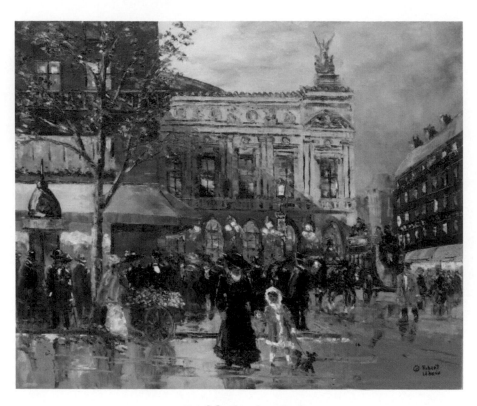

Café de la Paix

20" x 24" Ca. 1999

Collection of Albert L Rolon

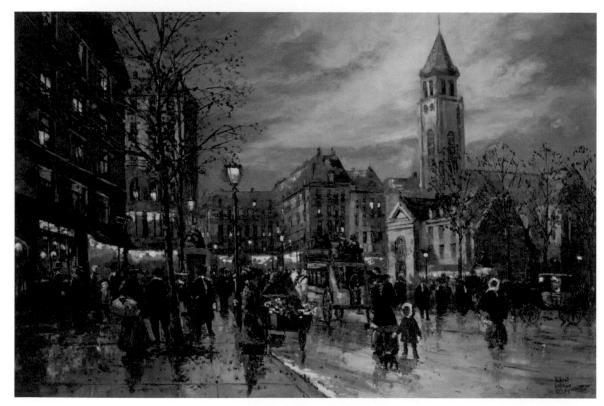

St. Germain des Pres

24" x 36"" Ca. 1998

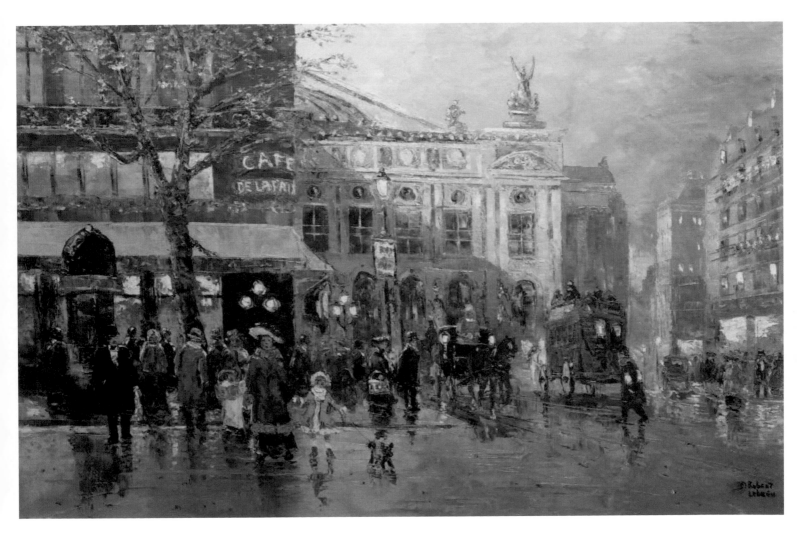

Café de la Paix

24" x 36" Ca. 2000

Courtesy of Nanette Richardson Fine Art

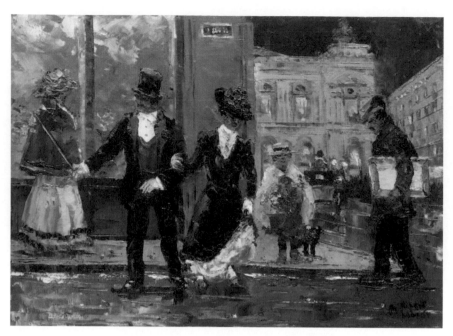

Not the Artists Evening

12" x 16" Ca. 2000

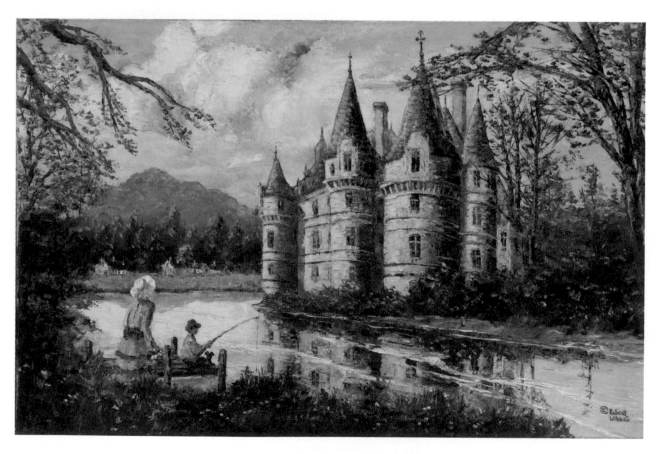

Chateau de Mesnieres – en – Bray

24" x 36" Ca. 2001

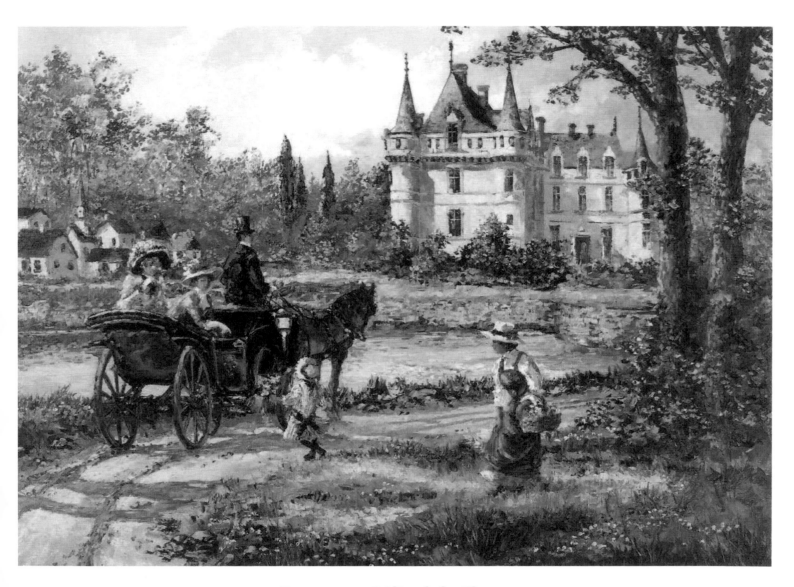

Return to M'Lady's Chateau

30" x 40" Ca. 1990

London

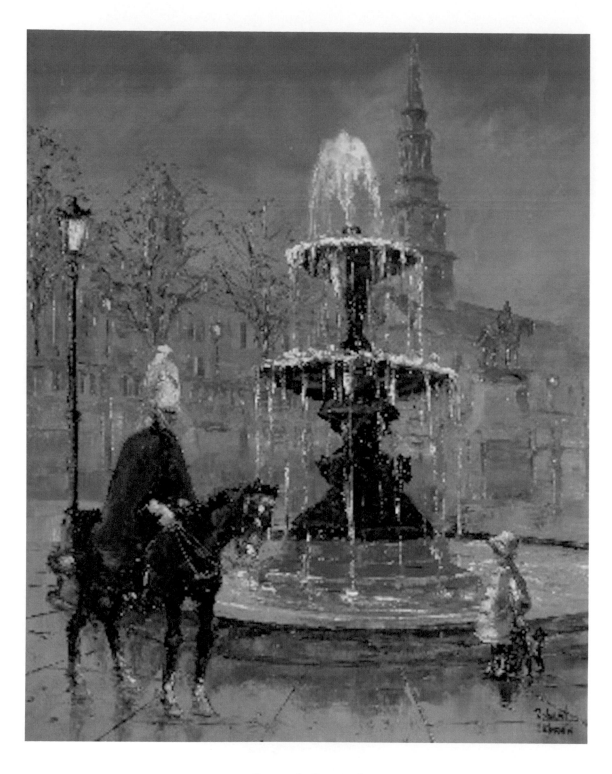

Royal Guard

20" x 16" Ca. 1982

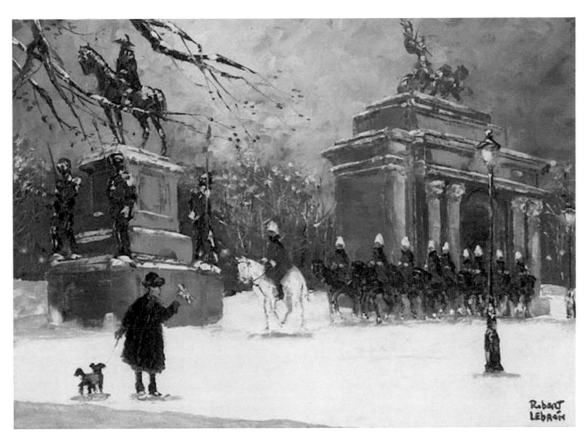

London Wellington
12" x 16" Ca. 1978
Private Collection

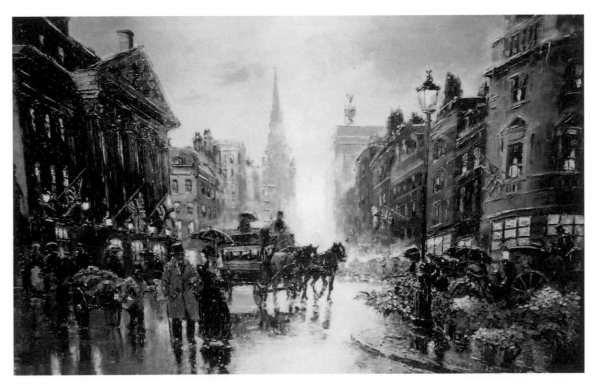

London Street Scene
18" x 24" Ca. 1980

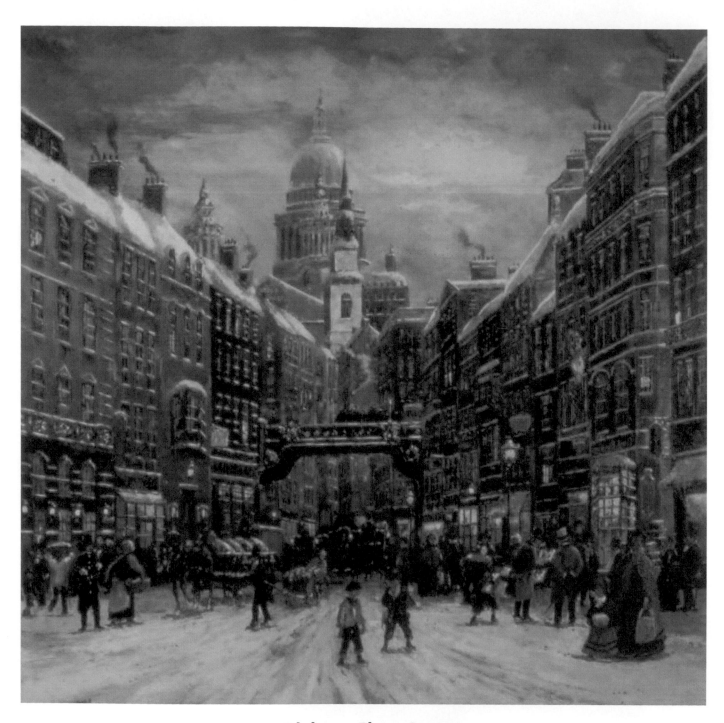

Dickens Fleet Street
60" x 60" Ca. 1993

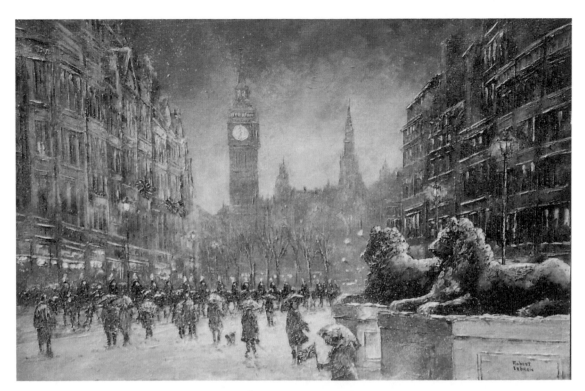

Trafalgar Square
24" x 36" Ca. 1997

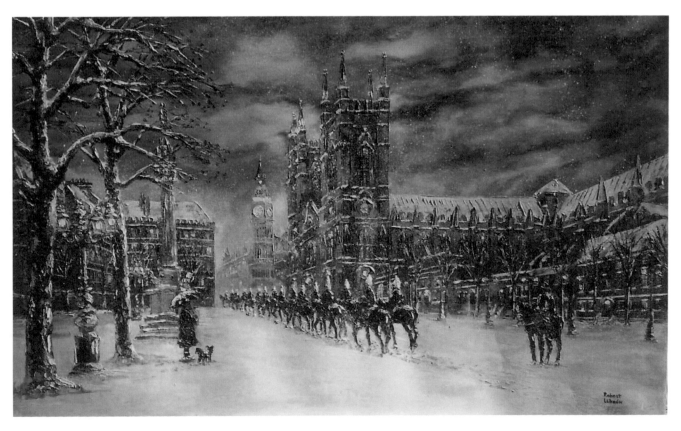

Westminster Abbey
36" x 48" Ca. 1996

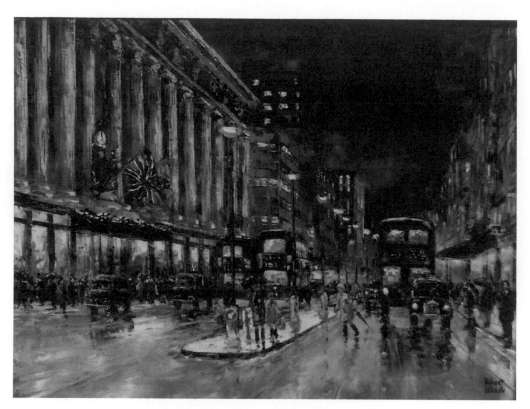

Selfridge Department Store
24" x 30" Ca. 1996
Private Collection

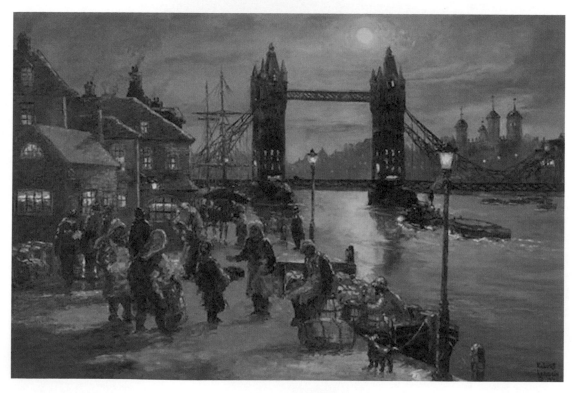

Tower Bridge
24" x 36" Ca. 1996

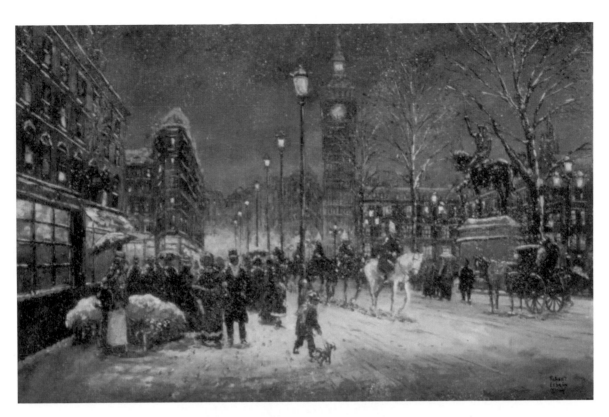

Big Ben and the Royal Guard
36" x 48" Ca. 1998

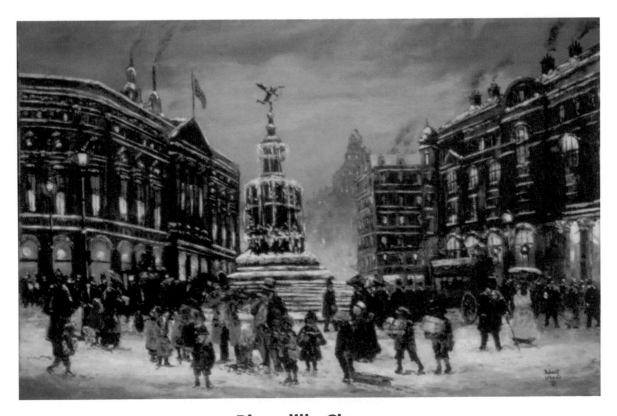

Piccadilly Circus
18" x 24" Ca. 1998

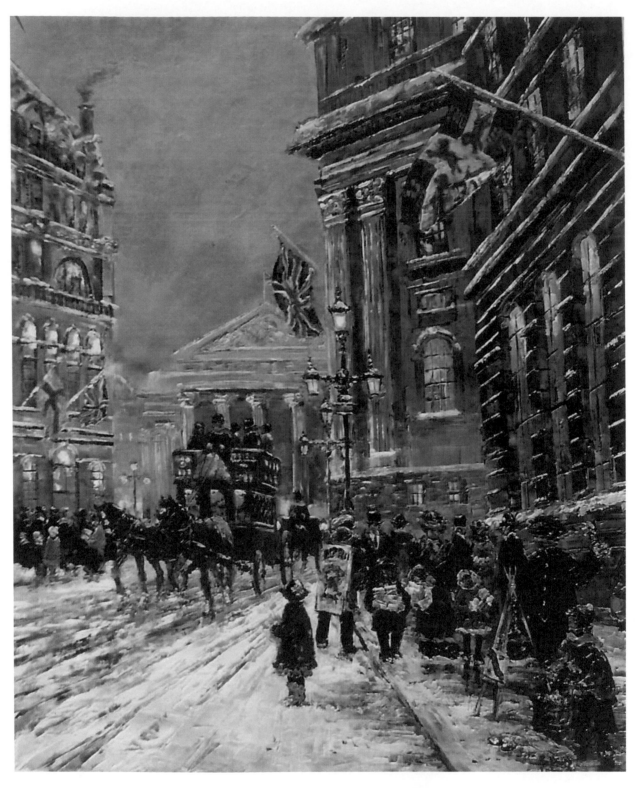

Financial District London

30" x 24" Ca. 1995

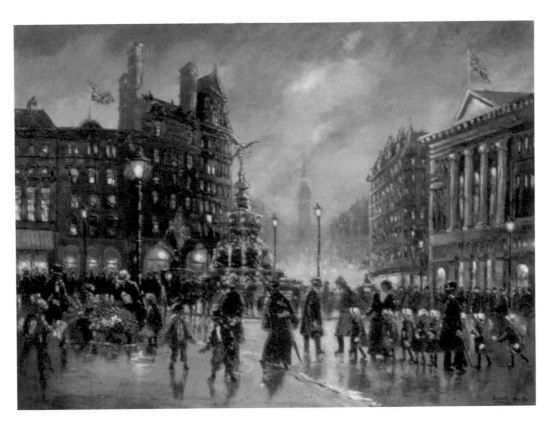

School Girls at Piccadilly Circus
30" x 40" Ca. 1995

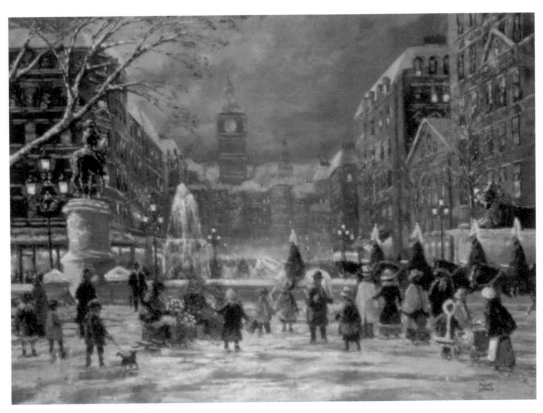

Royal Guard at Trafalgar Square
30" x 40" Ca. 1994

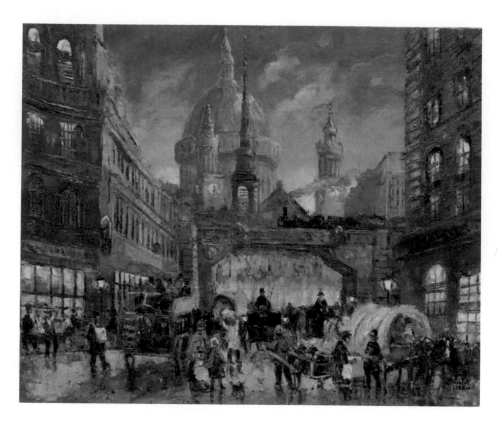

St. Paul's Catedral
20" x 24" Ca. 1998

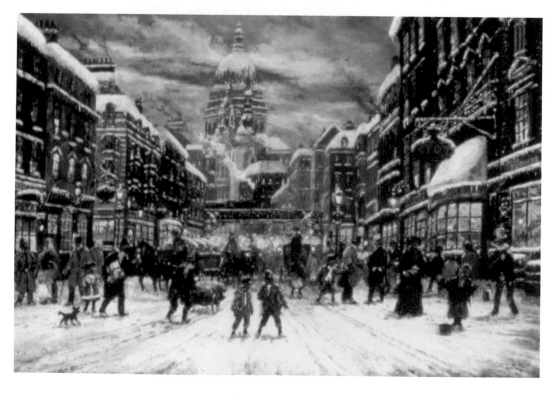

London Circa 1830
24" x 36" Ca. 1996

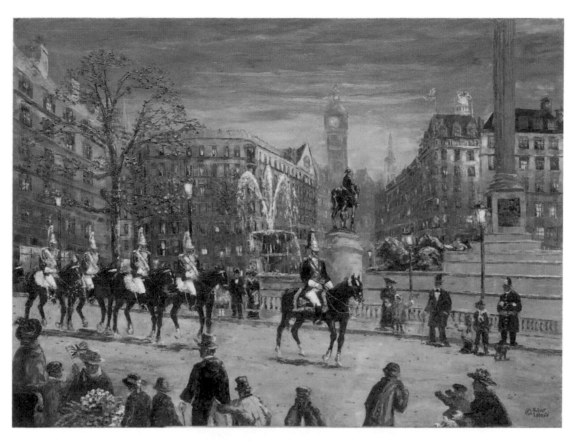

Trafalgar Square at Dusk
24" x 36" Ca. 2000

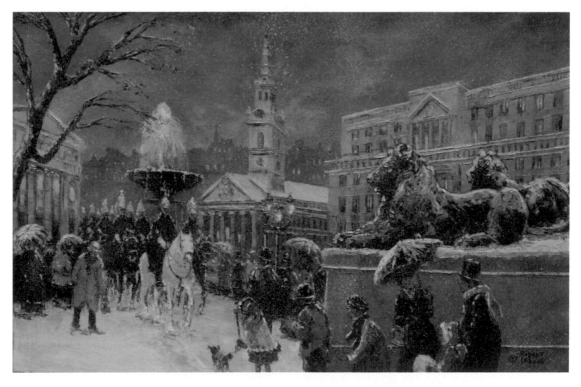

Trafalgar Square with Royal Guard
24" x 36" Ca. 2000

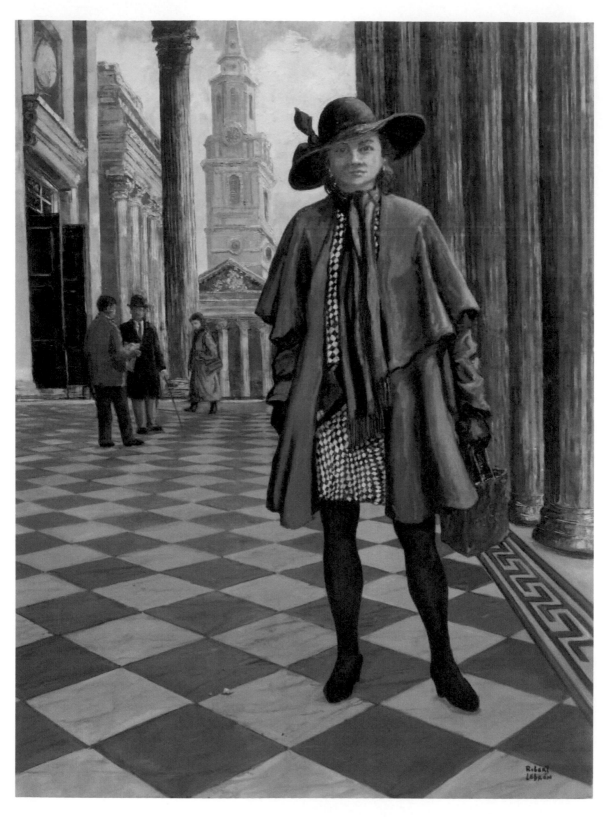

Sandi Lebron after James Tissot's "London Visitors"
48" x 36" Ca. 1995
Collection of Sandi Lebron

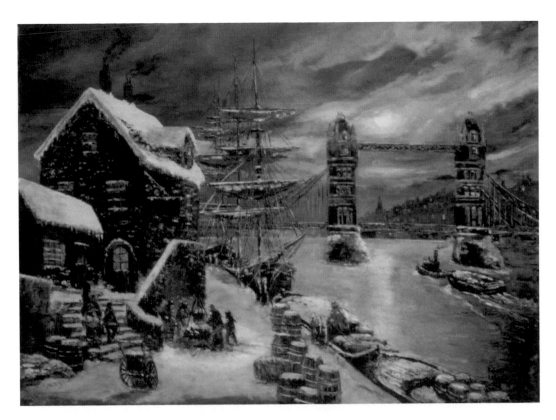

Tower Bridge Winter
30" x 40" Ca. 1997

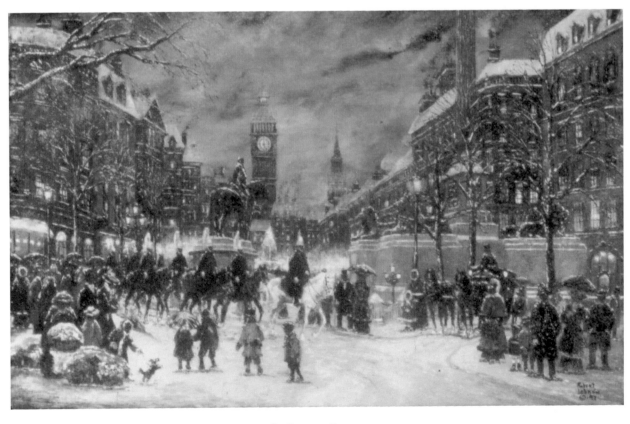

Trafalgar Square
40" x 60" Ca. 1997

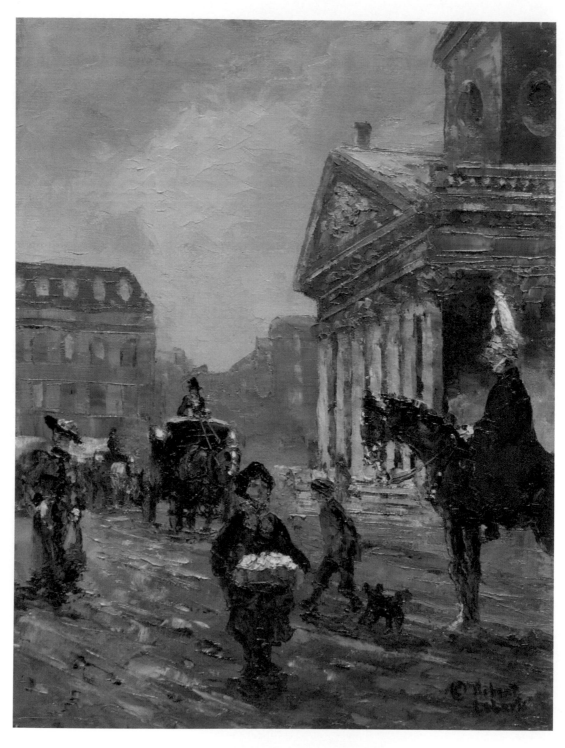

St. Martin-in-the-Fields
16" x 12" Ca. 2000

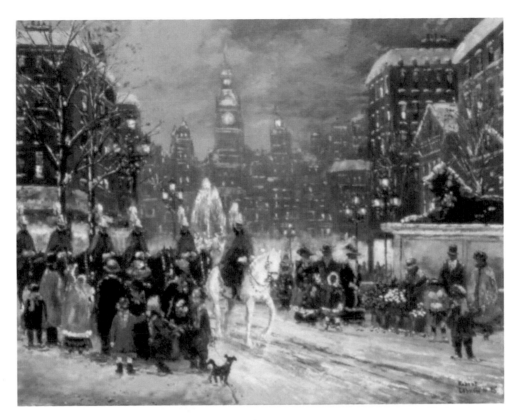

Trafalgar Square at Night
30" x 40" Ca. 1995

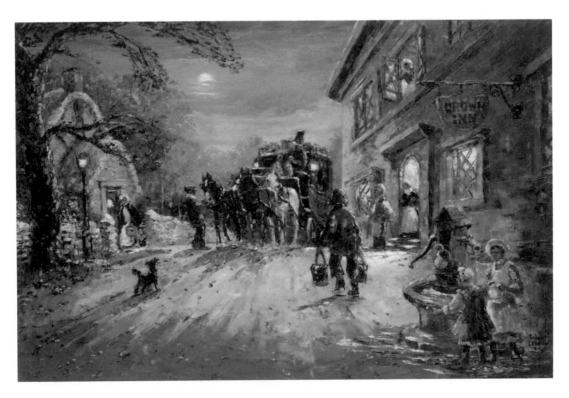

Crown Inn
24" x 36" Ca. 1998

More Paintings by Robert Lebron

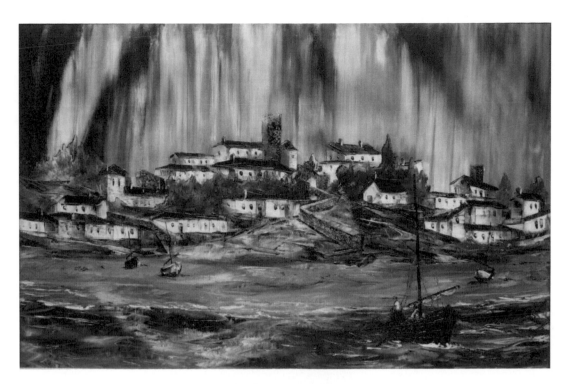

Malaga Spain
24" x 36" Ca. 1964
Collection of Albert L Rolon

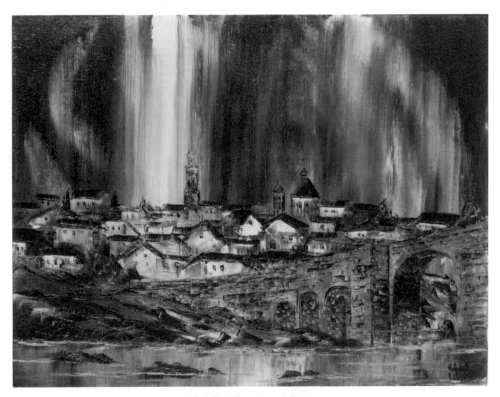

Toledo Spain
16" x 20" Ca. 1965
Collection of Albert L Rolon

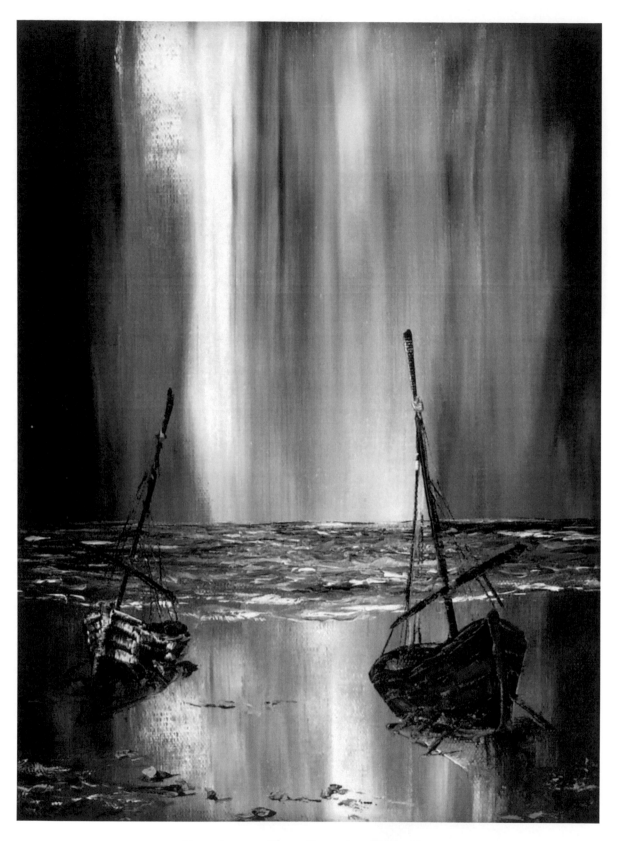

Boats on the Coast of Spain
12" x 9" Ca. 1964
Collection of Angelo and Dawn Mazzola

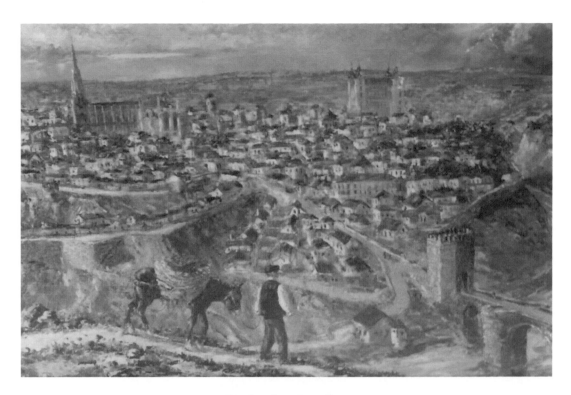

Toledo Spain
16" x 20" Ca. 1982

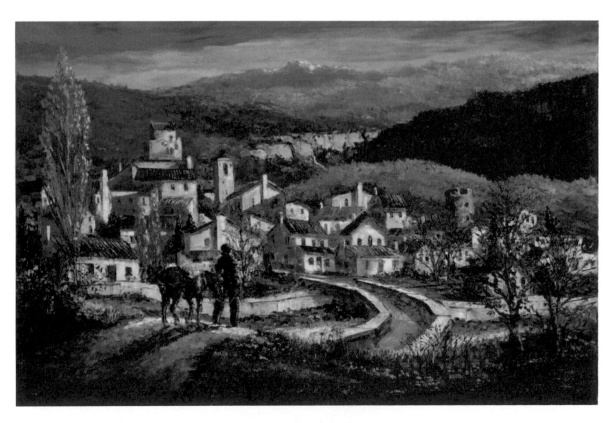

Spanish Village
24" x 36" 1998

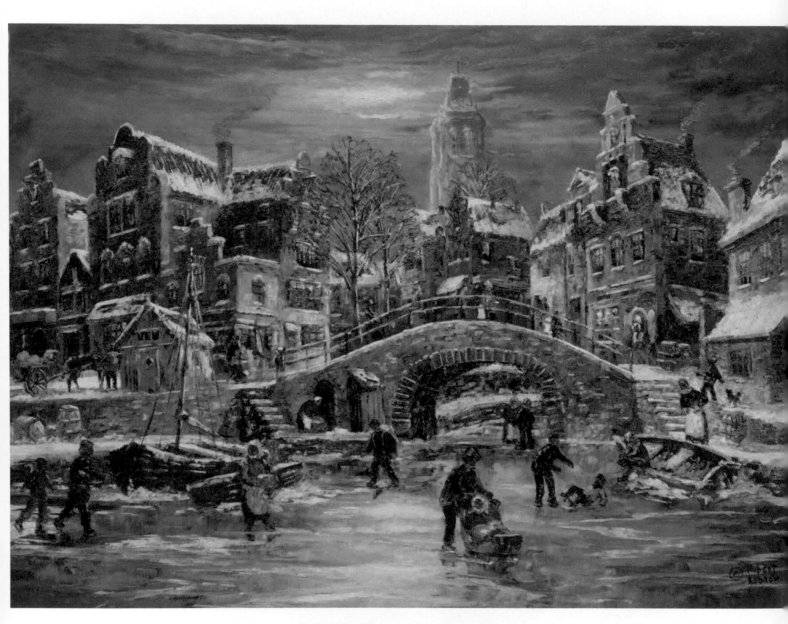

Amsterdam Ice Skating

30" x 40" 1997

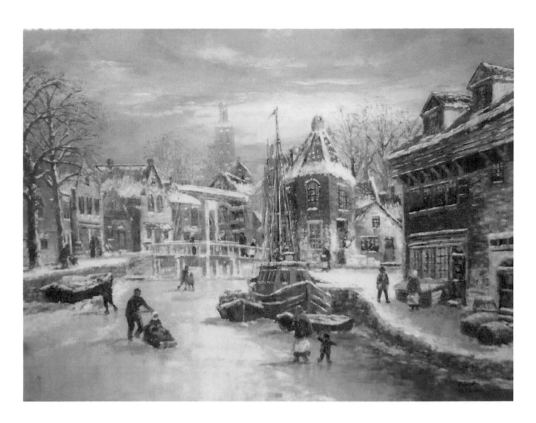

Amsterdam Winter
18" x 24" 1994

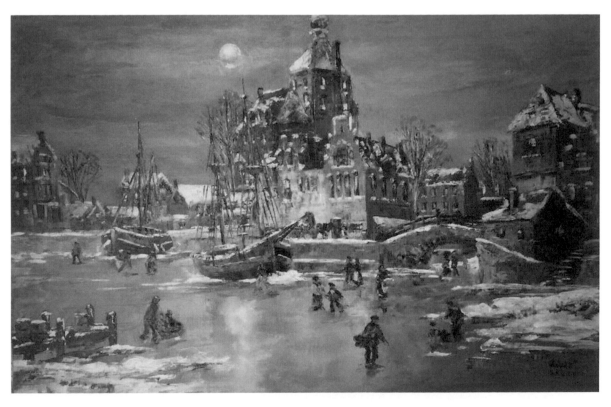

Amsterdam
24" x 36" 1996

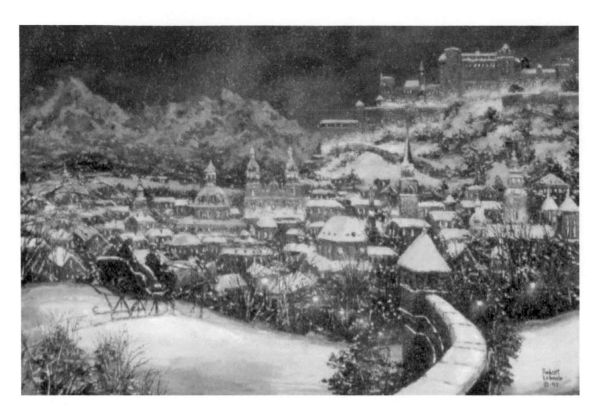

Salzburg, Austria at Twilight
24" x 30" 1997

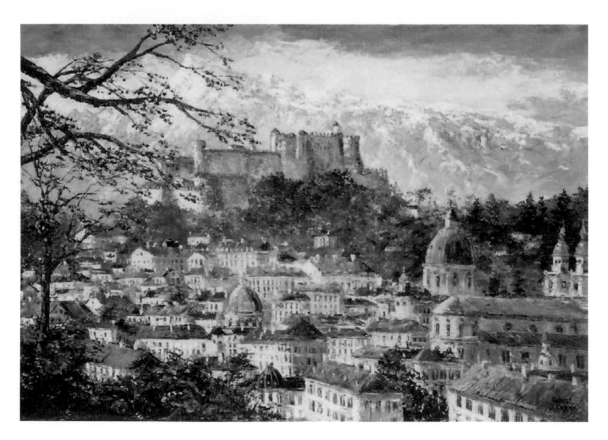

Salzburg in the Springtime
24" x 36" 1995

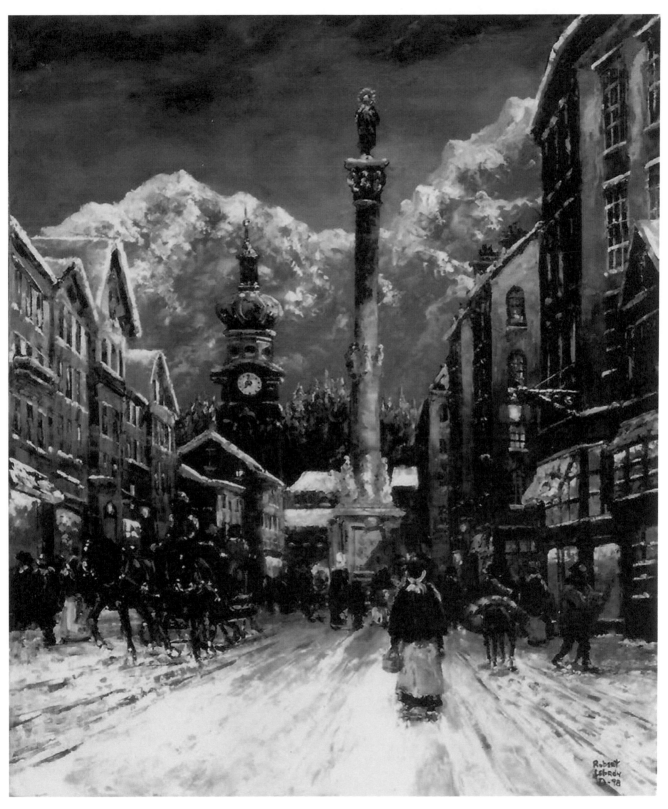

Salzburg, Austria
24" x 18" 1998

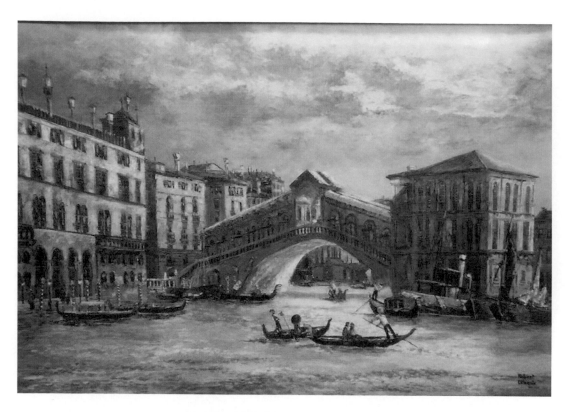

Rialto Bridge Venice, Italy
24" x 36" 1996

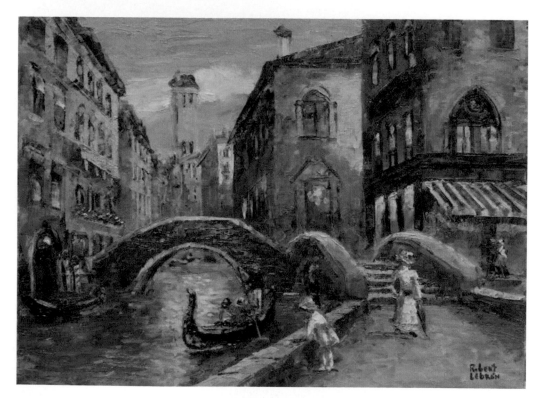

Venice, Italy
12" x 16" 1997
Private Collection

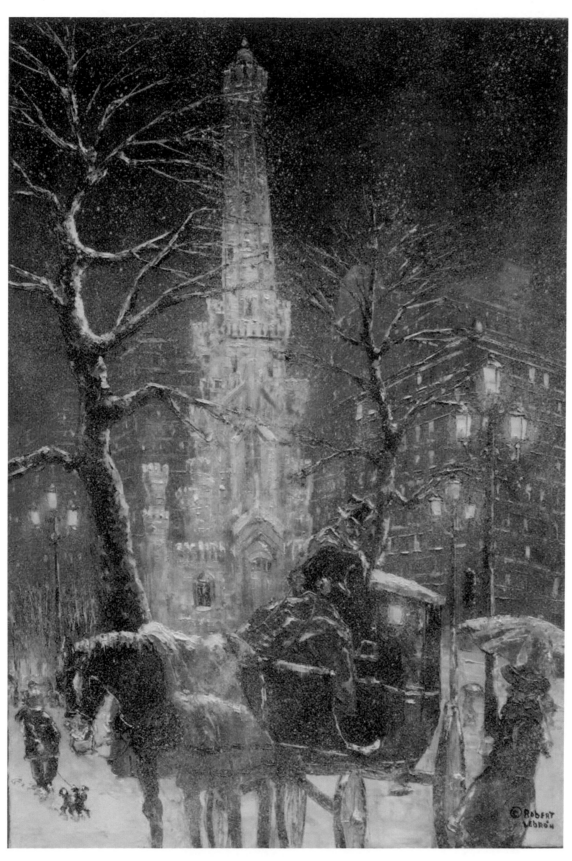

Chicago Water Tower
36" x 24" 1995

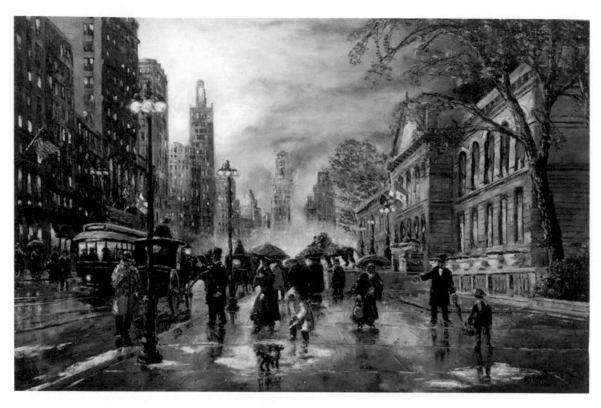

Chicago Art Institute
32" x 48" 1995
Collection of Daniel Fowler

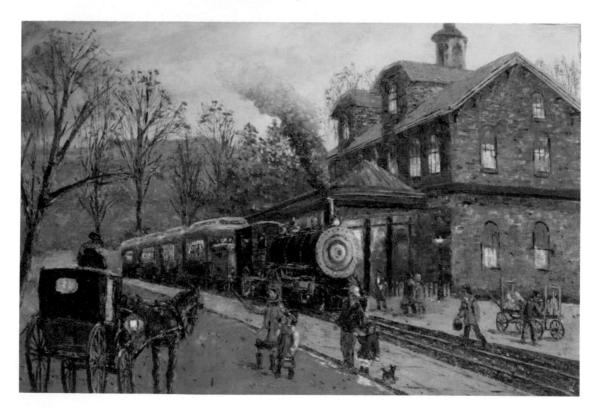

New Hope Train Station
24" x 36" 1998

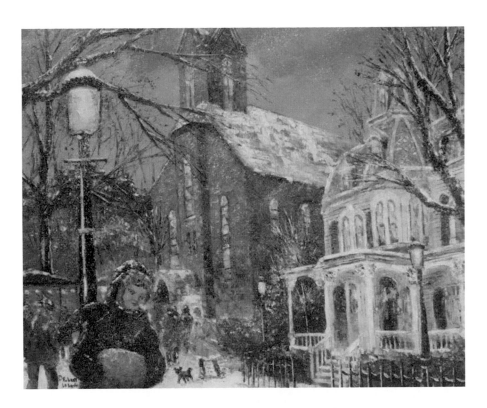

New Hope Pennsylvania
20" x 24" 2000

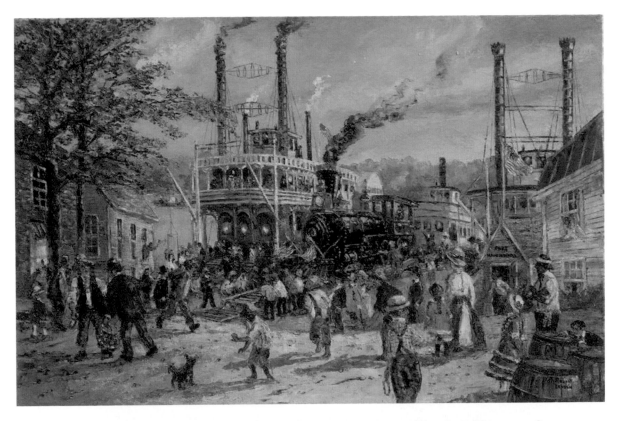

Mark Twain's Boyhood Home Hannibal, Missouri
24" x 36" 2001

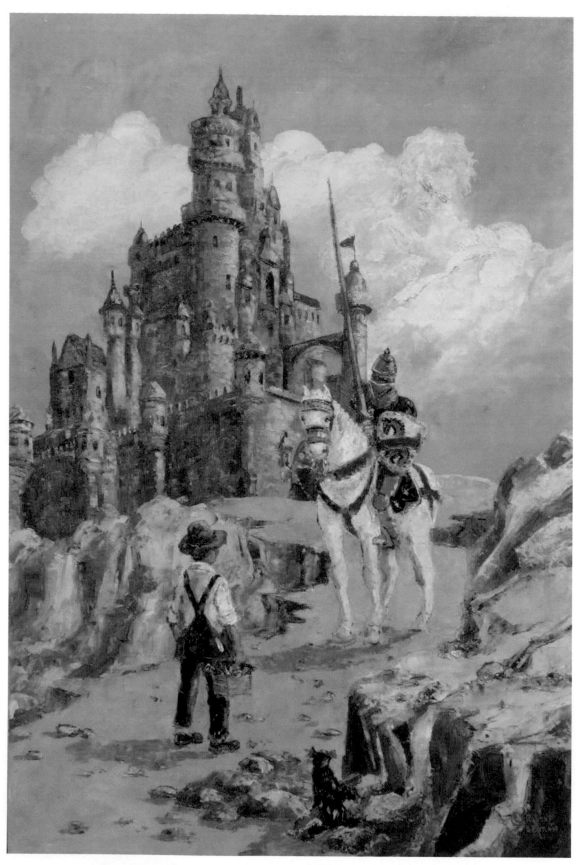

Connecticut Yankee in King Arthur's Court
36" x 24" 1999

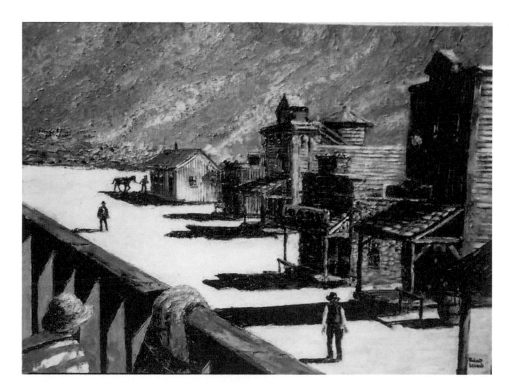

High Noon
20" x 24" 2002

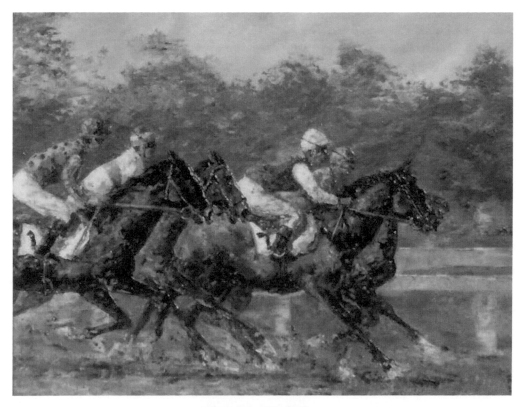

Photo Finish
20" x 24" 1982

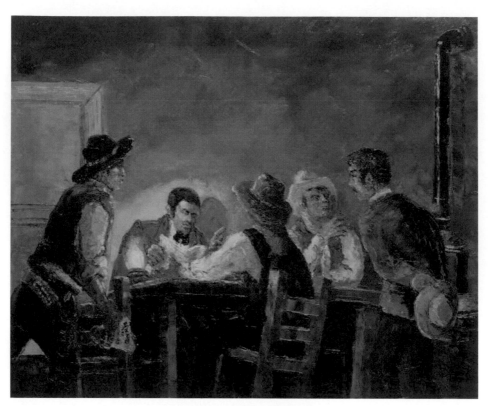

Jesse and Gang
20" x 24" 2003
Courtesy of Nanette Richardson Fine Art

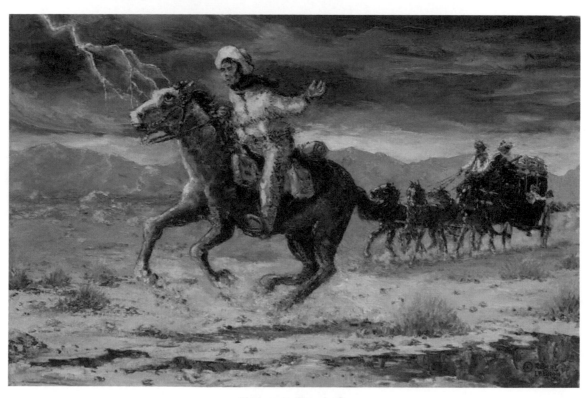

Stage Coach
24" x 36" 2002

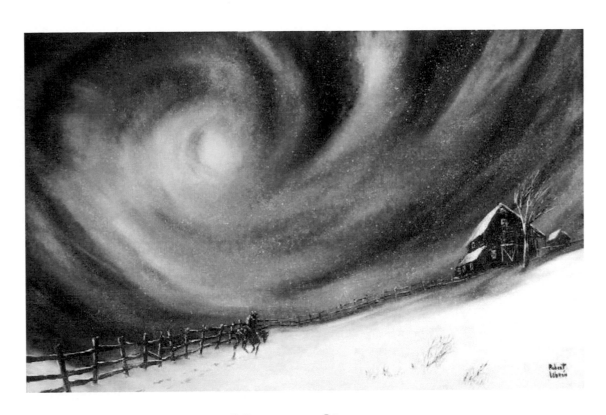

Montana Storm
24" x 36" 1968
Collection of Angelo and Dawn Mazzola

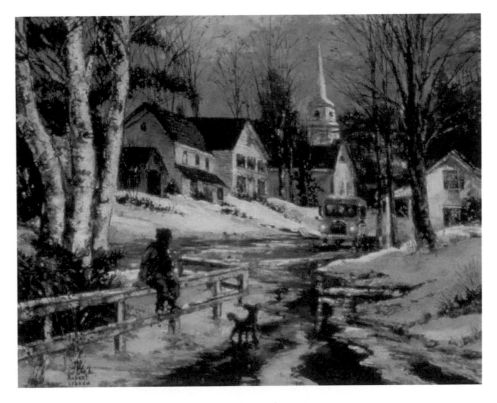

New England School Bus
18" x 24" 1993

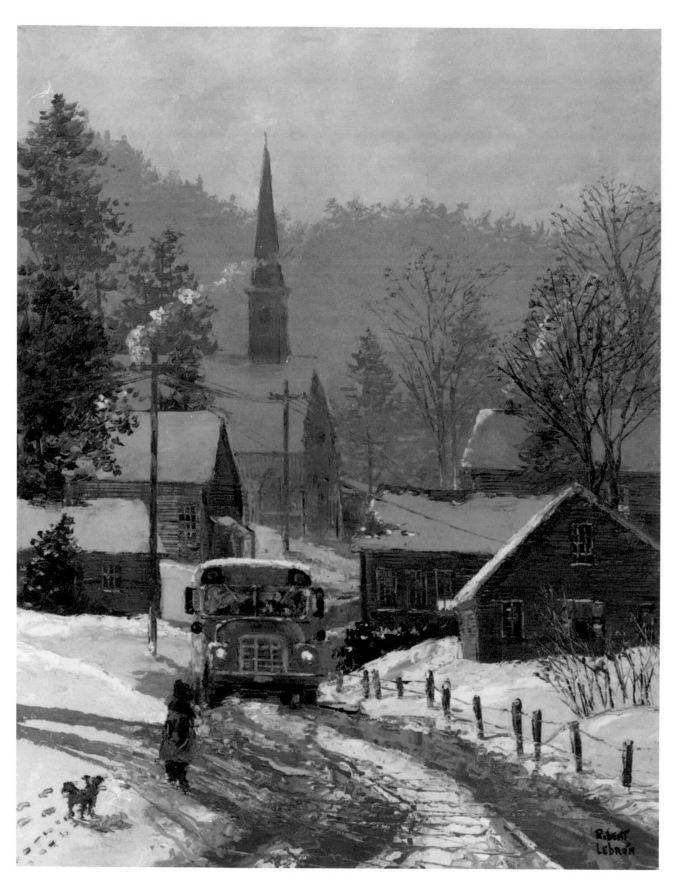

Snowy Morning

36" x 24" 1996

Private Collection

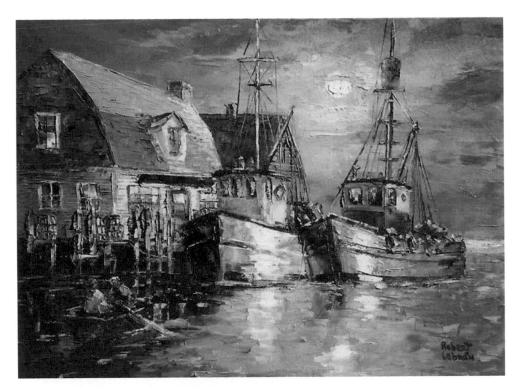

New England Pier
20" x 24" 1990

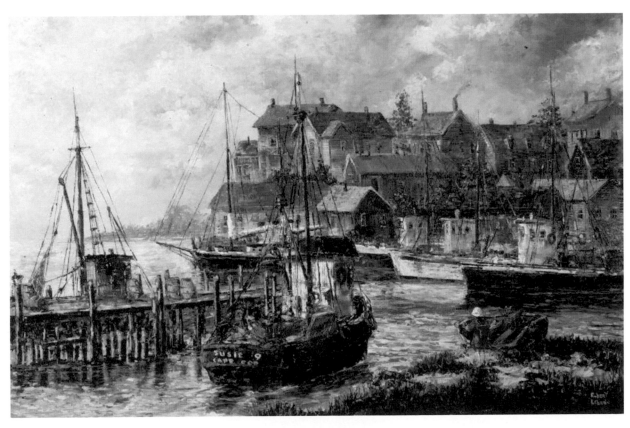

Mystic Connecticut
18" x 24" 1993

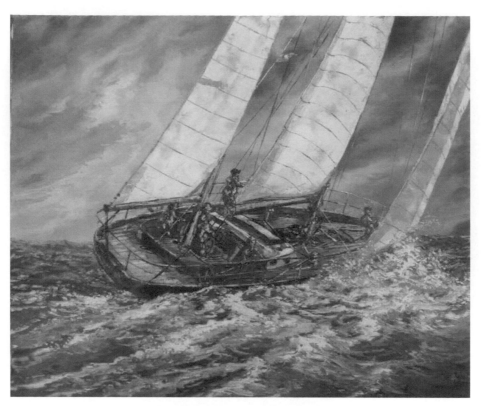

Sailing Rough Seas
20" x 24" 1984
Collection of Jeffrey Bissett

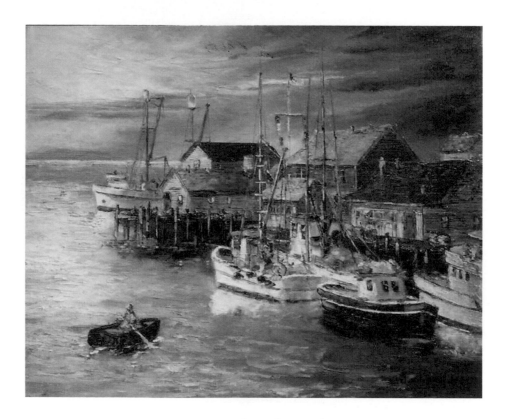

New England Harbor
20" x 24" 1986

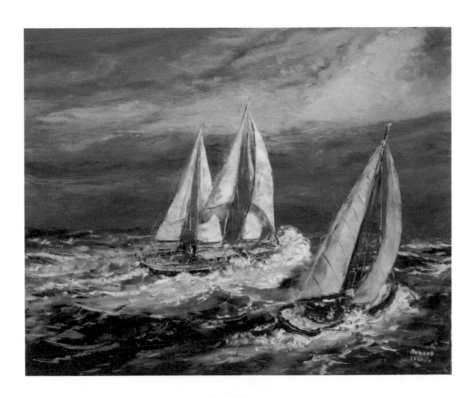

Sailing
20" x 24" Ca. 1998

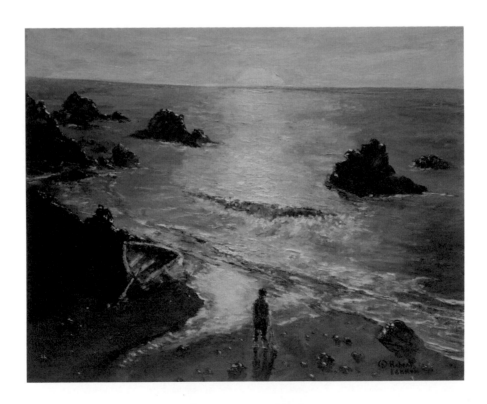

The Long Wait
20" x 24" Ca. 1999

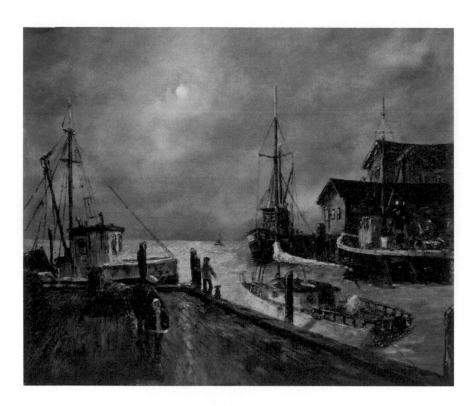

Harbor at Dusk
20" x 24" Ca. 1982

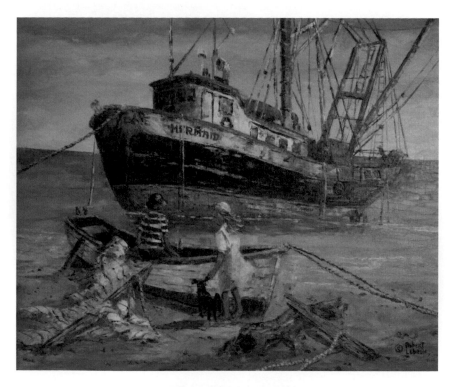

The Mermaid
20" x 24" Ca.1998
Collection of Albert L Rolon

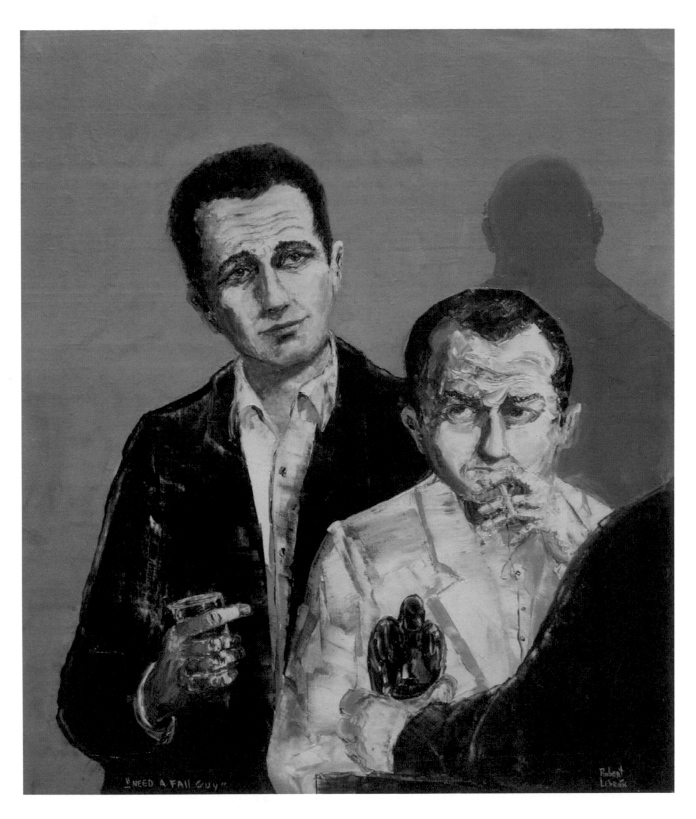

Humphrey Bogart and the Maltese Falcon
24" x 20" Ca. 1970

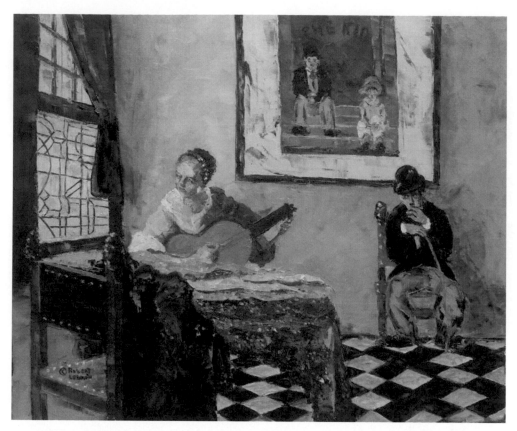

Vermeer's Woman with Lute and Charlie Chaplin
20" x 24" Ca. 2005

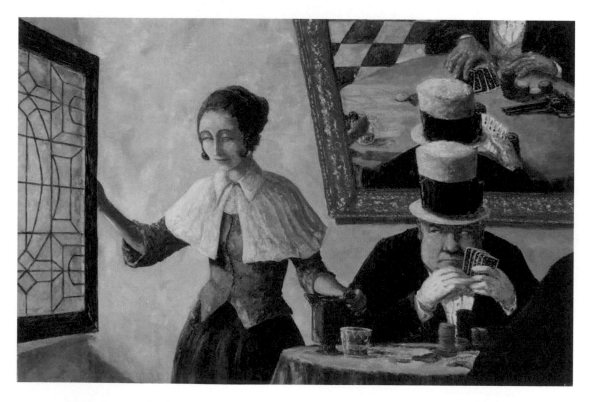

Vermeer's Woman with Water Jug and W.C. Fields
24" x 36" Ca. 1978

Galleries and Exhibitions

Art Gallery of Viera	Viera, FL	2000s
Artech International Gallery	Denver, CO	1990s
Bank's Fine Art	Dallas, TX	1990s
Bois of New Hope Fine Art	New Hope, PA	1990s – 2000s
Brennen Gallery	Scottsdale, AR Carmel & Palm Desert, CA	1980s – 2000
Centurion Galleries	Chicago, IL	1990s – 2000
Charles Hecht Galleries	Tarzana, CA	1908s – 2000
Danville Gallery	Danville, CA	1990s
Douglas Gallery	Stamford, CT	1970 – 1980s
Galleria Studio	Madrid, Spain	1960s
Gallery at Lincoln Center	New York City, NY	1980s
Gibson Galleries	Carmel by the Sea, CA	2000s
Hermitage Gallery	Rochester, MI	1990s – 2000
Hilliard Gallery	Kansas City, MO	1990s
Island Art Gallery	Manteo, NC	1970s – 1980s
Jean Marie Gallery	New York City, NY	1999

Lindsey Gallery	Carmel by the Sea, CA	1980s
Madison Avenue Gallery	New York City, NY	1980s – 1990s
Nanette Richardson Fine Art	San Antonio, TX	2000s
Old Queens Gallery	New Brunswick, NJ	1960s
Royale Galleries Inc.	New York City, NY	2000s
Sutton Gallery	New Orleans, LA	1990s
Thanhardt – Burger Corp.	LaPorte, IN	1960s
Village Gallery	Venice, FL	1990s

Robert Lebron at Work

Wall St./Trinity Church Painting

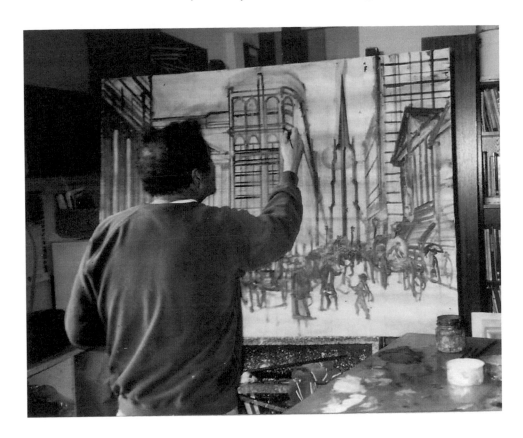

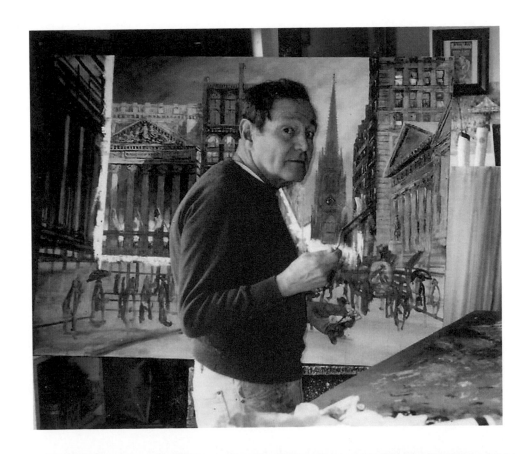

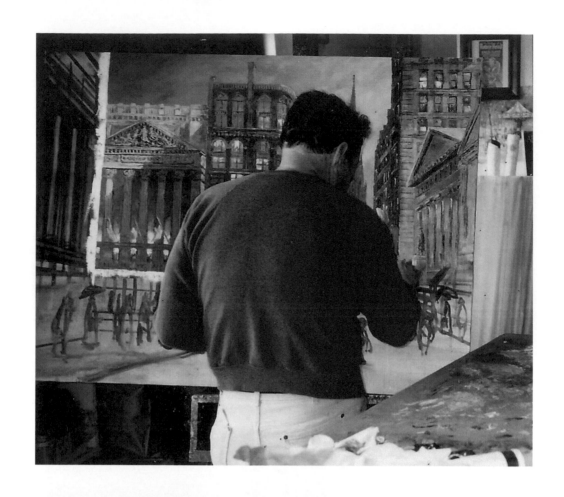

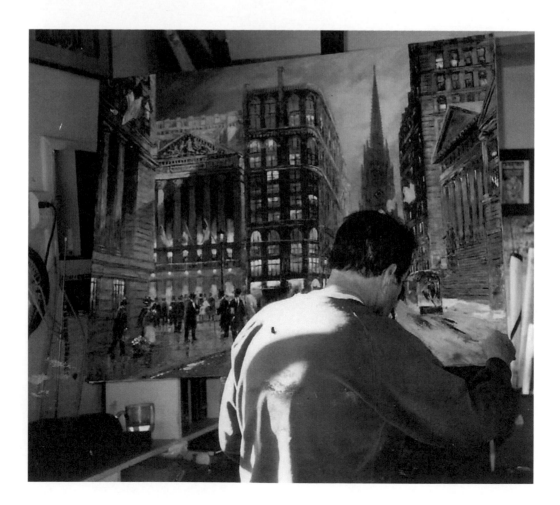

Lightning Source UK Ltd.
Milton Keynes UK
UKIC01n0131170115
244642UK00006B/7